CREATING WITH PLASTER

by DONA Z. MEILACH

REILLY & LEE COMPANY

CHICAGO

Foreword and Acknowledgements

From artifacts in the tombs of Egyptian kings, through Renaissance frescoes to modern sculpture, plaster has been a basic medium of the creative artist. Plaster, most often associated with sculpture, has applications far beyond this limit. The modern manufacture of various kinds of plaster has given the material a broader scope than ever.

Plaster is inexpensive, readily available and easy to work with. A material that may be used flat or in three dimensions, it can be sculpted or modeled, poured and cast. Its versatility allows teachers, camp directors, hobbyists, craftsmen and professionals to use it extensively. It is invaluable for learning the elements of design.

This book is intended to acquaint you with the types of plaster and allied materials now available which may be applied to the projects illustrated. The use of plaster is limited only by the imagination. It may be combined with many other materials to create unusual textures, shapes and color effects.

The examples illustrated are offered not to be copied but to serve as springboards for ideas from which to develop original projects. Historical and architectural uses of plaster are shown to make the reader aware of its wide application.

Gathering the material for this book has been an exciting, stimulating experience which has taken me into the studios of dozens of artists and the classrooms of many schools. It has involved correspondence with artists, teachers and museums in several countries.

I am particularly indebted to the teachers, schools and students who made work available for my camera. Mrs. Ruth Felton, Palos West School, Palos, Illinois, Sister Mary Augusta, Mother McAuley School, Chicago, Mr. Don Seiden, Institute of Design, Illinois Institute of Technology, (I. I. T.), Chicago, and their students became absorbed in the project. They created excellent examples too numerous to include.

I appreciate the cooperation of other schools in allowing me to photograph student work. Museums, art galleries, manufacturers, magazines and private art collectors enthusiastically shared the latest ideas and techniques. To the many individual artists who contributed their examples and experiences, my sincerest thanks.

Dona Z. Meilach
Chicago

CONTENTS

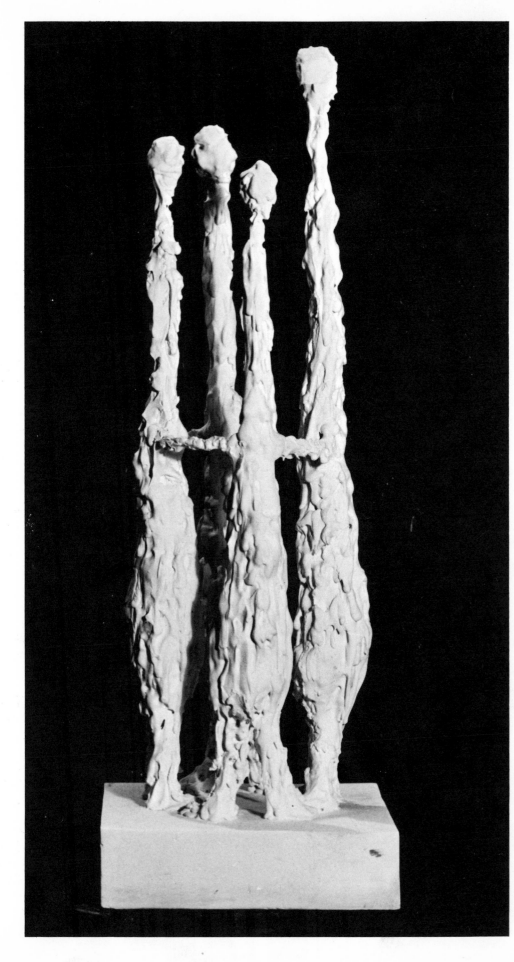

1. RING AROUND THE ROSY *Sister Joseph Ann, St. Xavier College, Chicago.*

chapter 1
WHAT IS PLASTER?

Mention the word "plaster" and most people will think of plaster of Paris. Actually, there are many kinds of plaster with varying qualities, all products of "gypsum."

What is gypsum?

Gypsum is a mineral rock first found in the earth thousands of years ago. The Greeks are probably responsible for giving it its name: *ge* meaning the earth and *epsum* meaning to concoct. They found that treatment of the raw gypsum with heat resulted in a white powdery product which we call plaster today.

Plaster appears in statuary discovered in the pyramids of Egypt, dating back about five thousand years, and in the ruins of Greek and Roman architecture. The noted French chemist, Lavoisier, developed methods which led to the commercial production of plaster in about 1755. Mining of gypsum grew around Paris because of the particularly rich deposit of the mineral rock in the area. From this early geographical association the name "plaster of Paris" was derived.

During the eighteenth century, most of the plaster produced was used in the building trades. Early artistic expression in plaster was highly developed in interior room decorations.

Sculptors usually thought of plaster only as a "sketch" material. They claimed it chipped, broke, soiled quickly and did not have the permanence of metals. Yet such plaster sketches have remained in remarkably good condition throughout hundreds of years, probably because they were handled carefully and always kept indoors.

Today, plaster is produced in France, the United States and some European countries primarily for use in the building and construction trades. But the artist and the art teacher are discovering that its potential as a creative material is comparatively unexplored. Also, they are recognizing that new methods of "calcining" (heating the gypsum until it oxidizes to become powdery plaster) result in a variety of plasters. Some are harder and therefore more chip- and break-resistant. Synthetic plasters have been developed. Cements may be used interchangeably with plaster when a more lasting quality is required for outdoor use.

Before undertaking any of the projects illustrated in this book, you should be familiar with the properties of different plasters and similar materials. They are described thoroughly in Chapter 6. When you select a material for a specific purpose you should consider the following:

1. Setting Time.—Some plasters set in two to three minutes; others allow you up to thirty minutes before hardening. Setting time is important in working with children.

2. Drying Time.—Plaster is dry when all the water has been evaporated out of the sculpture, usually in about twenty-four hours.

3. Texture.—Is the plaster fine or coarse? Certain sculptures may look better executed in a rough rather than a finely textured material.

4. Density, Strength, Workability.—Soft plasters are easy to carve and shave. Harder plasters are more difficult to carve and shave but are more durable.

5. Porousness.—This quality often determines the type of paint you may use in the final decoration.

1.—In this example, hydrocal, a type of plaster, has been applied to a wire armature. The final surface was developed by dripping the plaster on the figures.

WHAT CAN BE DONE WITH PLASTER?

Plaster is an extremely versatile art material. It can be used for casting, molding, dripping, embedding, sculpting, decorating and building over a variety of armatures. It may be used to create sculptures in the round or relief designs. It adapts easily to mixtures and combinations of other materials for a multitude of textural effects. Color may be achieved by using almost any type of paint. The color may be added to the wet plaster or placed on the dry finished model; often the result will be unpredictable, but beautiful. Whether the material is in the hands of a young student or a master like Auguste Rodin, a successful work of art can be accomplished. Like any other art medium, the material must simply be the vehicle for creating work where the design elements are the prime consideration. Throughout this book, the examples are offered to illustrate design concepts, the variety of projects possible, texture and color. For specific color and texture methods, refer to the Technical Notes in Chapter 6.

2.—From blocks of plaster, the student designed and carved these abstract shapes by using knives, files, sandpaper and other instruments. The plaster is smooth and remains in its natural white.

3.—Hemp dipped in plaster and worked over a wire armature can produce a variety of shapes that are either solid, or open and airy. The rough texture of hemp gives the finished sculpture a highly textural appearance and tremendous strength.

4.—Rodin used plaster as though it were a marble block. But unlike marble, plaster can be added to as well as chipped away from a form. From this plaster model, a bronze casting was made.

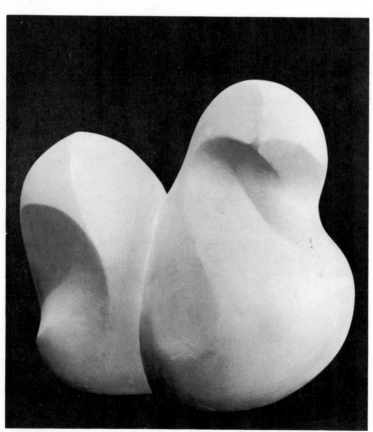

2. BIRDS *Student, High School of Music and Art, New York.*

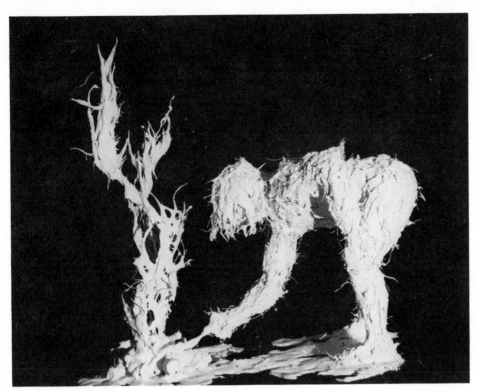

3. **LIGHT THE FIRE** *Albert Vrana*

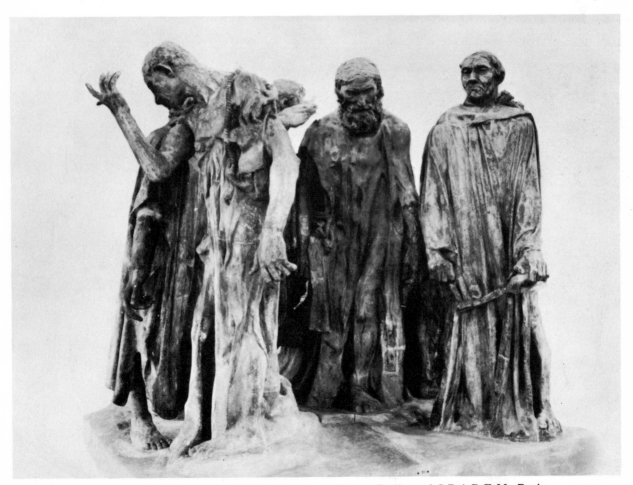

4. **BURGHERS OF CALAIS** *Auguste Rodin. Courtesy, Musee Rodin and S.P.A.D.E.M., Paris.*

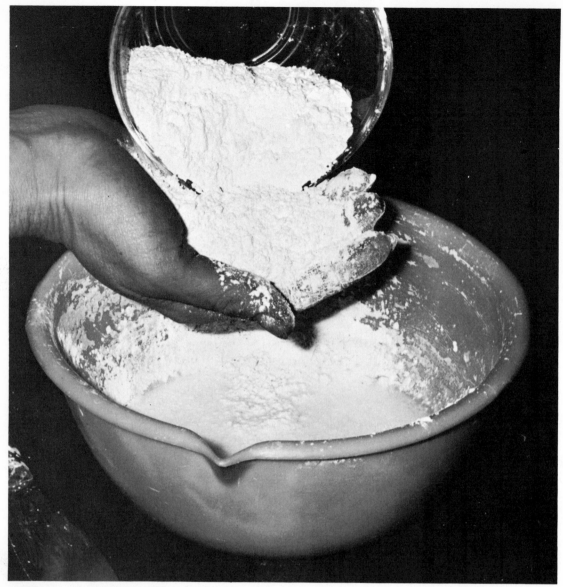

5. Sift plaster through your hands into the water

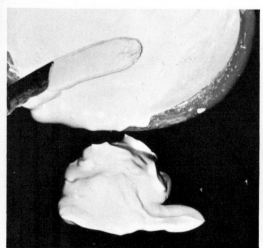

6. Creamy pouring consistency

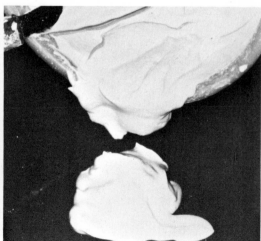

7. Beginning to set

8. Hardened plaster

HOW TO PREPARE AND USE PLASTER

Plaster comes as a white powder and must be mixed with water that is about at room temperature. The water-to-plaster ratio varies but generally is about one part of water to two parts of plaster.

Bowls of rubber or containers of plastic are best for mixing vessels because their flexibility makes them easy to clean. A child's rubber ball cut in half works well. Allow excess plaster to dry in the bowl, then simply flex and bend the bowl to loosen the scraps. Also, rubbing the bowl with a very thin coat of vaseline aids in clean up. Disposable vessels such as aluminum foil pans, waxed milk cartons and waxed paper cups are excellent for classroom use. Never add fresh plaster to a bowl with dried plaster chips because the mix will be lumpy and unusable.

A liquid-like wax material brushed on the sides and bottom of the molding container will facilitate removing plaster casts from their molds. A plaster object when duplicated from a plaster mold must be thoroughly waxed so the two forms will separate when dry. Vaseline is the most easily available separating medium; it may be melted or diluted with carbon tetrachloride to simplify spreading. P.F. Soap-parting is made specifically for the purpose. Automobile paste wax, Krylon plastic spray, tincture of green soap and some grease cutting detergents will also do the job. Experimentation may be required to learn what works best on a particular mold. The separating medium may be removed by washing it off under very hot water.

Slick, smooth working surfaces such as formica and glass are best because dried plaster may be chipped off easily. Waxed paper will protect working areas and is very satisfactory for young children because the plaster will not adhere to the waxed paper. Newspapers will protect working surfaces also, but will stick to the plaster if the two materials come in contact.

Waste plaster should never be poured down a drain! It may harden and clog the drainage system. Allow excess plaster to dry, then put it in waste containers. Wet plaster may be poured into old newspapers, allowed to harden and then thrown out.

5.—Always place the room-temperature water in the mixing bowl first. (If the water is too hot, plaster will set too quickly; cold water will retard setting.) Sift the plaster through your fingers and into the water slowly and evenly to break down any lumps. Allow the plaster to soak for about two minutes undisturbed to permit time for a film of water to surround most of the plaster grains.

6.—When the plaster is absorbed use a spatula, a spoon or your hands to mix. Stir gently from the bottom up until all the plaster is wet and there are no lumps. Avoid whipping or beating the mixture or air bubbles will form. If the mixture is too thick, more water may be added. However, if the mixture is too thin, adding more plaster will weaken the final cast because the first solution of plaster already will have begun its chemical action.

7.—The ideal mixture has a creamy, pouring consistency. Generally, a too thin mixture will be drippy, a too thick mixture will set too quickly. After you have made a few batches of plaster, you will get the feel of the right density. When the mix has been sufficiently stirred, tap the bowl gently on the worktable so that excess air bubbles will come to the top. When you fill a mold, vibrating the table or the container will also help the plaster seep into fine lines and produce a more satisfactory result.

8.—As the plaster continues to absorb the water, its crystals harden and interlock quickly, resulting in the "setting" action. This stage of hardness is reached in about five minutes after spatula mixing has occurred. The plaster tends to expand slightly and become warm as it hardens.

6

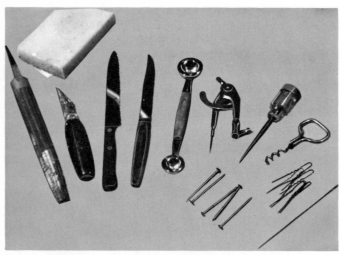

9.

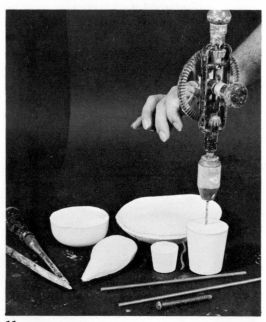

10.

11.

TOOLS TO USE WITH PLASTER

A plaster form may be altered considerably by smoothing, roughening, digging and scraping with any variety of tools. While the plaster is hardening, it is possible to make impressions, add textures, dig holes and gouges, sand, smooth and scratch lines into it until the last moment. Plaster may be kept damp for longer periods by wrapping it in plastic or self-adhering food wrap, which slows down the drying process and allows more time to work on the piece in a damp condition.

9.—Special plaster finishing tools such as these spatulas, scrapers, saw-toothed instruments and chippers, made of quality forged steel, are indispensable to the professional artist.

10.—Tools from the kitchen drawer and the tool chest can produce exciting results also. A wet sponge is used to smooth the plaster before it is thoroughly dry. Rasps, chippers, knives, melon ballers, compass points, nails, combs, etc., may all be used effectively to create interesting designs and textures. A sponge should be kept in a can of water so it does not harden from the plaster it picks up. All tools should be immersed in water as you use them and washed immediately after use.

11.—When plaster is hard, it may be treated much like wood. Drills, burrs, chisels, scrapers and many other tools may be used for making designs or assembling plaster forms.

12.—Sophomore students in the art class of Mother McAuley School, Chicago, create large and small figures by placing plaster-soaked rags over armatures of wire screening. Here several students share a pan full of plaster. Newspapers are spread to protect the table.

13.—Applying the finishing touches. These figures were created in four forty-minute class periods.

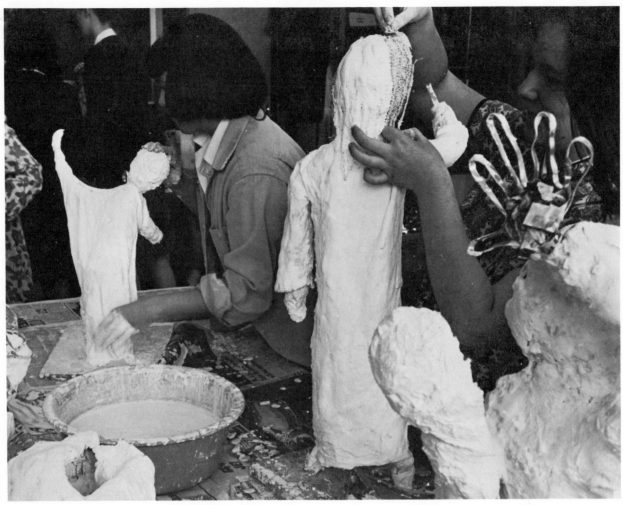

12.

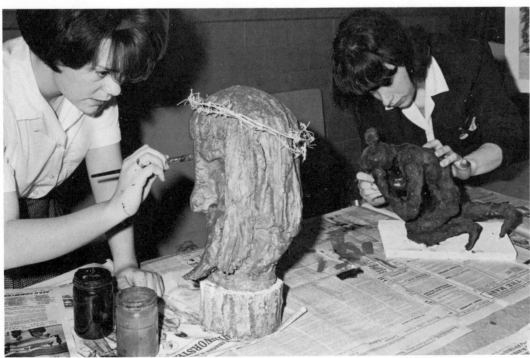

13.

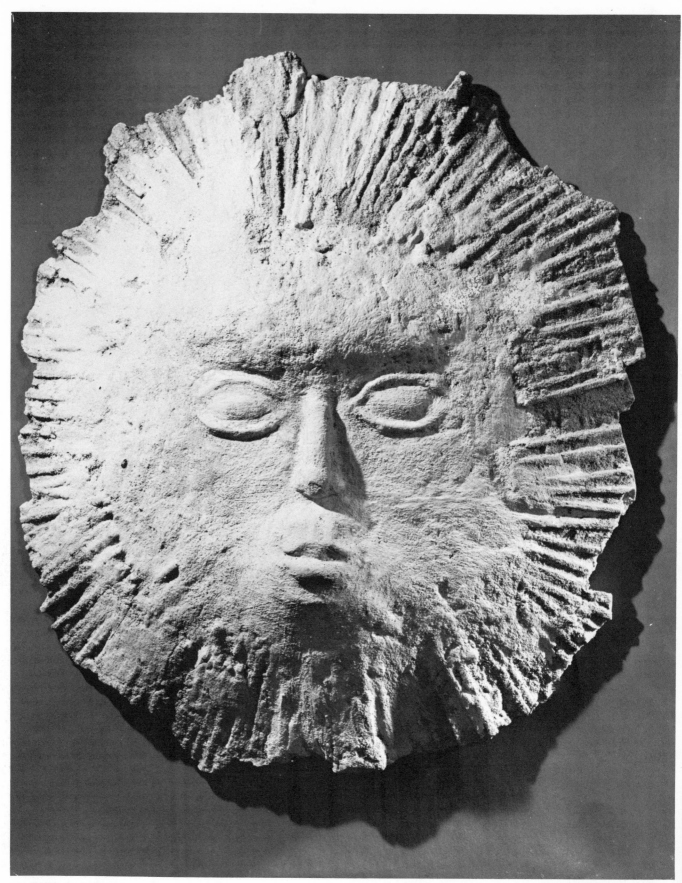

14. SUN *Jack Denst*

chapter 2
CASTING WITH PLASTER

The process of casting involves pouring into a mold a liquid material, which hardens and takes the shape of the mold. There are many materials that can be molds for plaster castings. Included are sand, clay, cardboard, plaster itself, styrofoam and many of the new plastic materials. From some molds only one casting can be made; from others the casting can be duplicated many times.

SAND CASTING

Sand is a popular and versatile material for creating the negative mold for plaster and cement casting. Sandcastings can be found as wall hangings, room dividers, garden figures, relief sculptures on building facades, interior wall and room decorations.

A sand mold may be used only once because the process of casting destroys it. Therefore each sandcasting produces an individual piece of sculpture. Sandcastings are easy and fun to make. They require only materials found in the home or schoolroom, plus a bag of sand and a few pounds of plaster. A very impressive sculpture may cost only a few cents to create. Artists often make sandcastings directly in the sand at the beach, using water from the lake or ocean. (If ocean water is used, the salt content will hasten the setting of the plaster. *See* Technical Notes.)

You will require a frame or box to hold sand if you are working at home or in the schoolroom. A shoebox is fine for a small casting. Any sturdy cardboard carton will serve the purpose. A simple wooden frame made of four wooden slats nailed together can be placed on a flat surface. Cover the flat surface with a piece of plastic before putting the sand in the frame to prevent the sand from drying out and to make clean-up easier.

Sand should be moist enough so pattern edges hold up. Dry sand will crumble when plaster is poured into the mold. When you pour plaster into a sand mold (or any other kind of mold) begin from one corner and allow the plaster to flow out. If you begin from the center of the mold and radiate out, there is a greater tendency for the plaster to trap air bubbles.

14.—This sandcasting is thick in the center and thinner at the sides. The casting picks up the texture of the sand.

15.—Both a relief (raised) and an intaglio (lowered) surface can be obtained by the versatile sandcasting mold. The cast is always the reverse of the mold. Areas of sand that are raised become intaglio in the cast, and vice versa.

15. FLORAL POLYPTYCH *Gerrald Blackburn*

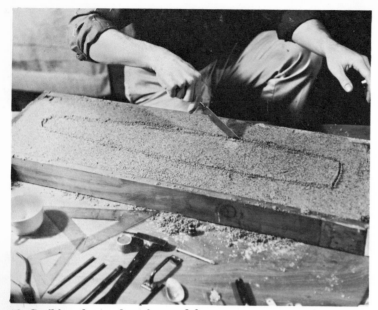

16. Scribing the sand set in wood frame

16.—Artist John Stribrny demonstrates his method for creating "God of Atlantis" (Fig. 20). Four pieces of wood are nailed together to form the frame for the sand. The sand is moistened, then leveled even with the top of the frame. The outline of the design is scribed on the surface of the sand, then cut deeply with a kitchen knife. Sand is scooped out to create the general overall contour. (The sand should be saved for it may be used many times.) The areas that are scooped deepest become the most protruding portion of the finished sculpture. Thin sections which result in weak points in the sculpture should be avoided.

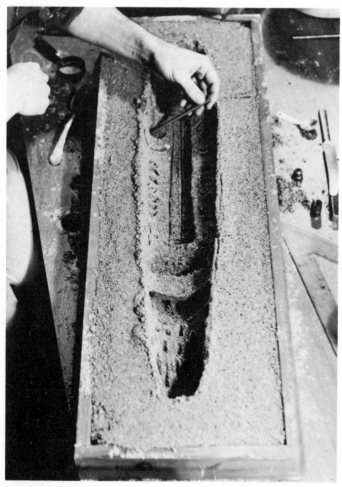

17. Designing

17.—Simple tools such as nails, a knife, scoop, washers, bottle opener and bottle caps are used to create the impressions and design.

18.—When the sand mold is complete, plaster is mixed about the consistency of heavy syrup so it flows easily from a spoon without breaking down the designs of the mold. Pouring begins at one end of the mold rather than from the center. Cement should be used if the casting will be placed outdoors.

If deep areas exist, fill these in first, then continue to fill in the mold until the plaster is level with the top of the sand. A piece of screen or a bent hanger may be embedded in the center of the sculpture to give it added strength. A screw eye, bent wire loop or two nails about an inch apart, embedded in the back, can be used as a hanging device. Wire is strung between the two nails to form the loop.

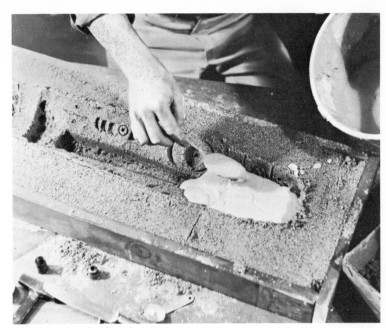

18. Spooning in the plaster

19.—The casting should be allowed to dry overnight. The sand is then spooned away from the sculpture around the edges. The casting is lifted out gently, with any thin areas carefully supported, and placed on a flat surface. The loose sand particles are brushed away with a stiff paint brush or a broom. Some sand may be washed off with water.

The sand remaining on the surface provides the texture for the sculpture. For a contrast of smooth and textured areas, sand may be scraped or sandpapered off in some places.

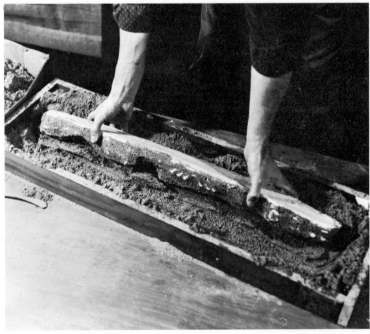

19. Removing the casting

20. GOD OF ATLANTIS *John Stribrny*

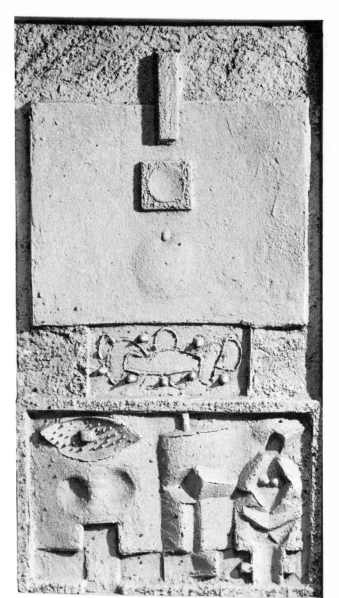

21. DEUS *Constantino Nivola. Collection, Whitney Museum of American Art, New York.*

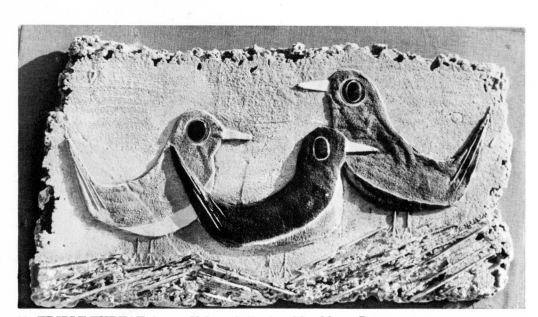

22. **TRIPLE THREAT** *George Nelson Collection, Mrs. Meyer Don*

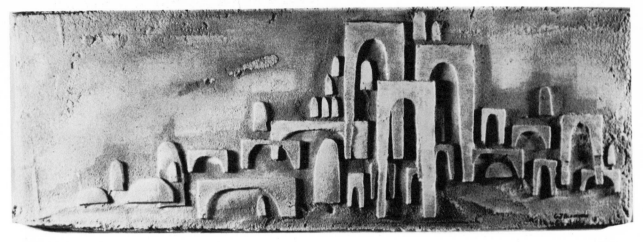

23. URBAN ARCHES *Gerrald Blackburn*

20.—The simple tools and method belie the complexity of the three-dimensional plaster result.

21.—Whimsy, geometry, contrasting forms and a variety of textures are possible with sand casting.

22.—A ragged edge adds interest to the bird forms, which have been brightly painted with a solution of fabric dyes applied to the damp casting.

23.—A feeling of depth is achieved by designing the forms so they appear to go behind one another. Some of the shapes actually are superimposed but some merely suggest overlapping. Several of the arches have been smoothed by sanding.

24.—Different colored smooth stones have been embedded in the centers of the flowers and the bird's eye, to carry through the use of organic forms with organic shapes of Nature. The stones are placed in the sand mold and set into the plaster as it hardens.

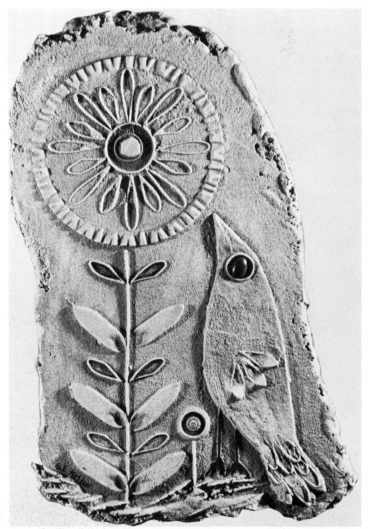

24. ONE GOOD TERN DESERVES ANOTHER *George Nelson*

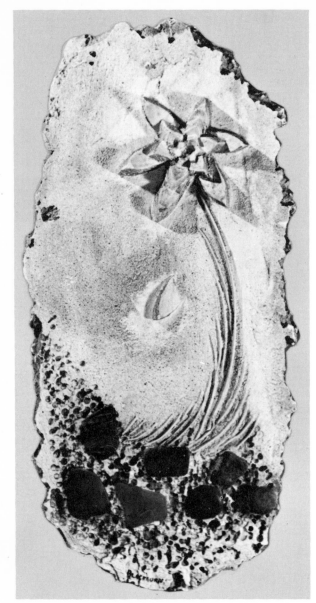

25. FLOWER WITH PEBBLES *Gerrald Blackburn*

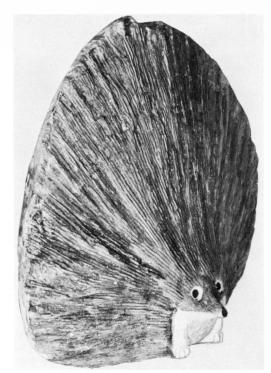

26. PORCUPINE *Gerrald Blackburn*

27. RACCOON *Gerrald Blackburn*

25.—Stones and pebbles add surface interest to the flower that seems to have an easy motion, despite the hard material from which it is made. A fine-grain sand was used for the mold; coarser sand will result in a rougher textured surface.

26.—This porcupine, cast in sand, was painted various tones of blacks and browns with a solution of fabric dye.

27.—Texture, color, shape and dimension make this stylized raccoon a favorite personality.

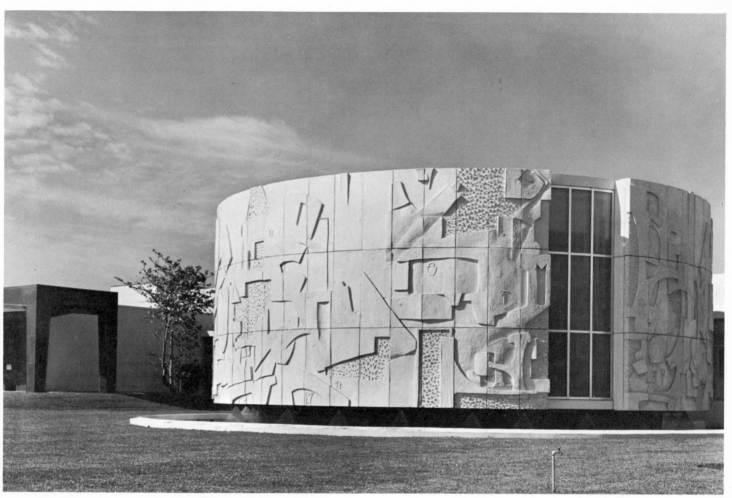

28. LIBRARY AUDITORIUM PANELS *Albert Vrana*

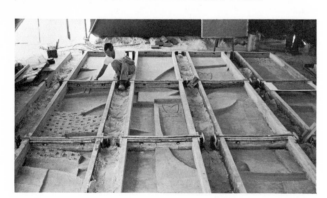

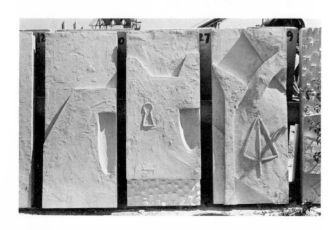

28.—The sandcasting method can be used for developing architectural decor, as illustrated in the facade of this library in Miami Beach, Florida. The symbols on the panels are designed to conduct the viewer from man's lowly beginning at the base of the building upward and outward into the ever widening scope of the future.

To create these panels, Albert Vrana first designed the panels on paper. Frames were built to the exacting architectural measurements. Experimentation enabled Vrana to use dry sand for the mold. He then placed dry portland cement on the sand and hosed it down with water. The cement particles absorbed sufficient water for setting, and the excess ran off through drains at the bottom of the mold.

28a.—The molds are shown ready for casting. The flow of the design continues from one panel to another.

28b.—Three panels are ready for assembling on the building.

29.

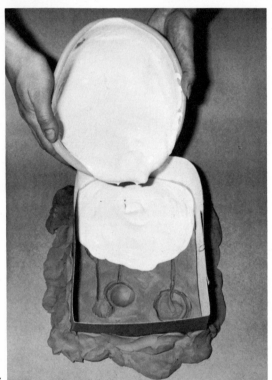

30.

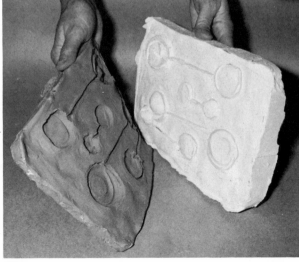

31.

CLAY CASTING

Plasticene clay is one of the most functional materials for preparing negative molds. It has a wax base and will not stick to plaster; water-base clays are not satisfactory.

The negative design is made in a slab of clay. As in sand casting, the clay mold is the reverse of the finished casting. Low areas in the clay will become high areas in the plaster, ridges in the clay will form grooves in the plaster.

Textures and forms from rug-backings, twigs, hardware, gears, chains, etc., may be impressed in the clay and then removed. The plaster will fill in the impression, and the design left by the object will appear in the plaster casting.

29.—Clay is easier to work with when it is softened by kneading or placing in a warm oven. Designs can be made with fingers, simple tools or clay-modeling tools.

30.—Place the form in a box or fashion a "wall" around it to retain the wet plaster, using a separating medium if cardboard is selected. This stiff paper wall is held firmly against the clay mold by shoring with clay, as shown.

Plaster is mixed to a creamy consistency and poured over the clay to about a three-quarter-inch depth. A loop of wire may be placed in the back before the wet plaster sets hard.

31.—After the cast dries thoroughly, separate the clay from the plaster. Smoothing and refining can be done on the dry plaster. A layer of screening, hemp or a wire laid into the plaster will give added strength to a large cast.

32.—Rounded shapes with smooth surfaces can be made from the clay mold, but the problem of retaining the plaster in the mold makes angular forms easier to work than free forms.

33.—Large metal letters were impressed in the clay in interesting arrangements. Additional pattern was worked into the broad areas of the letters and this relief casting is the final form.

34.—Chain, mesh, gears and a variety of other mechanical objects impressed in the clay mold resulted in this mechanical-looking design that could also represent plant forms.

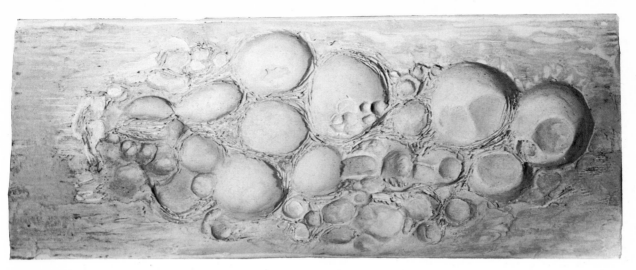

32. BUBBLE BUBBLE TOIL AND TROUBLE *Don Seiden*

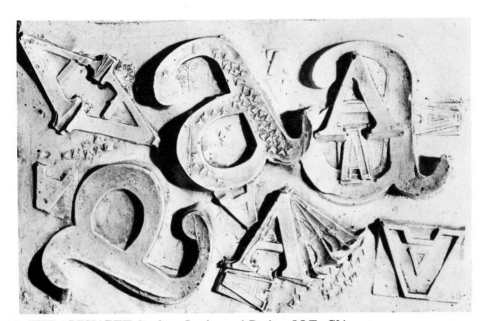

33. THE ALPHABET *Student, Institute of Design, I.I.T., Chicago.*

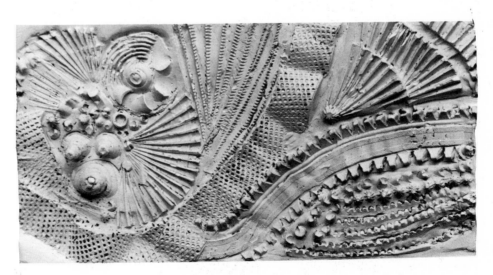

34. MECHANICAL PLAQUE *Student, Institute of Design, I.I.T., Chicago.*

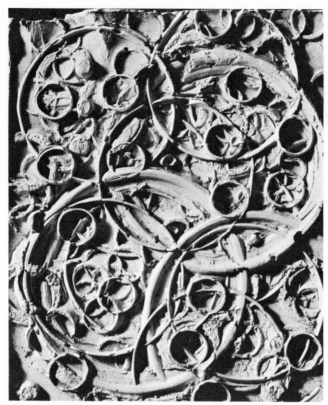

35. CIRCULAR FORMS *Student,*
Institute of Design, I.I.T., Chicago.

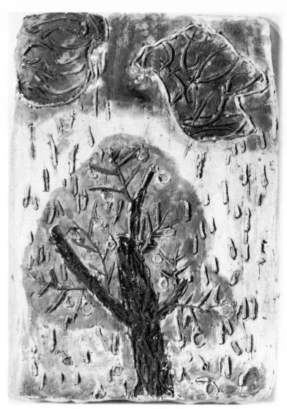

36. CLOUDBURST *Eighth-grade student*

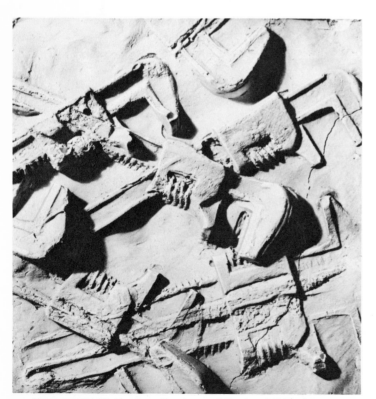

37. WRENCHES *Student, Institute of Design, I.I.T., Chicago.*

35.—A sensitive study in light and shade is illustrated in this plaster relief made from a clay mold. The ridges catch the shadows, which become an important aspect of the sculpture.

36.—A tree, clouds and rain have a primitive quality. The plaque was painted with temperas. Children from about fourth grade and up can work with the clay and plaster technique successfully.

37.—Utilitarian objects, when placed in interesting designs and poured in plaster, become a lesson in creative thinking. Learning to divorce an object from its function and make it "work" in a piece of art is the basis for much contemporary work in plaster and metal sculpture as well.

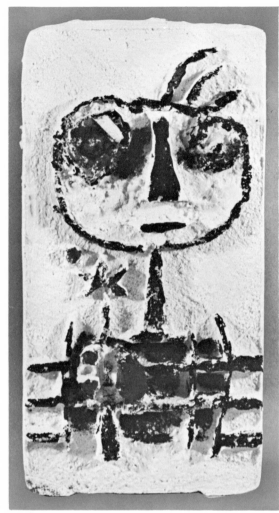

38. A LA MIRO *Dona Meilach*

39. Design is drawn on the Styrofoam

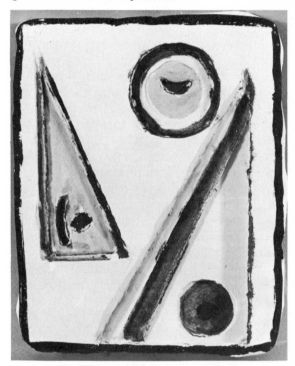

40. GEOMETRIC FORMS *Dona Meilach*

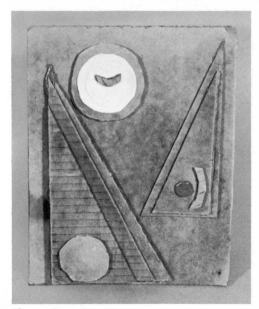

41. Cardboard mold

38.—Styrofoam, one of many new materials available to the person who wishes to experiment, also may be used for a mold.

39.—Prepare the Styrofoam by drawing on it first with a magic marker. Styrofoam is a little difficult to cut because knives dull quickly. Different levels can be obtained by cutting into the surface at various depths. Be sure to use a separating medium, and, if you don't want the rough texture of Styrofoam, fill in the surface pores by brushing on melted wax or vaseline and allowing it to harden.

40.—A mold of cardboard was made by gluing one piece on to another, then vaselining it well.

41.—Undercuts in the cardboard mold were filled in with coils of plasticene clay. The deep intaglio cast was painted with temperas after the plaster had dried.

chapter 3
PLASTER SCULPTURE

Sculpture is an art of arranging volumes in space. Design elements essential to a sculpture are the same as those of other art forms: shape, rhythm, line, color treatment and surface texture. However, sculpture, because it may be viewed from all sides, must have the elements placed in a three-dimensional relationship that does not exist in a flat piece of work such as a painting.

Sculpture generally falls into three classes: *in the round, relief* and *intaglio.* "In the round" refers to a three-dimensional shape which you walk around and view from numerous angles. "Relief" is sculpture in which the figures or shapes are attached to a background from which they project. (Most sandcastings are relief sculpture.) The least common is "intaglio," in which the design or figures are sunk into the background (Fig. 41).

Traditionally, sculpture in the round may be developed by two methods. The first is chiseling or carving a design from a block of marble, stone, plaster or other material. This is called the "subtractive" method because you are subtracting material to create the design. The other is the "additive" method which involves building up a form by adding plaster, clay or other medium over a support material called an armature. Today, artists are also building out from a central axis to give the effect of a cantilevered projection.

However, the versatility of plasters and cements allows us to work with them in both unconventional and traditional methods. The proof of the success of any method is the quality of the finished sculpture.

42, 43.—Adding one shape to another can be done with many forms of cones, rectangles, cubes, rounds, and half-rounds. Assembling the shapes in an artistic arrangement makes them sculptures. The basic shapes can be poured into containers such as bowls, halves of rubber balls, paper cups, plastic bags, cardboard tubes or almost anything one can improvise for the purpose.

When sanded and refined to the contours of the design, the forms may be assembled by gluing, or drilling holes and joining with metal rods, or by adhering one piece to another with additional plaster. The method of joining will depend on the size and shape of the pieces.

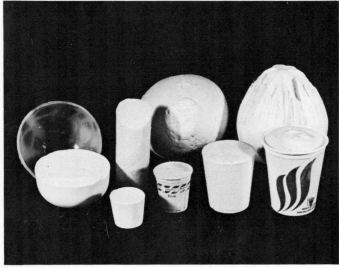

42.

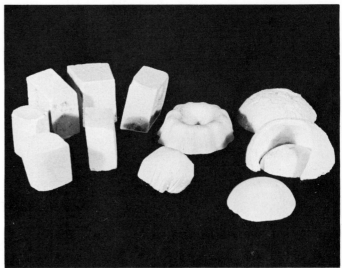

43.

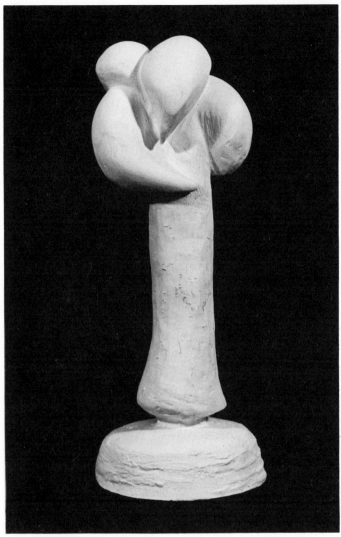

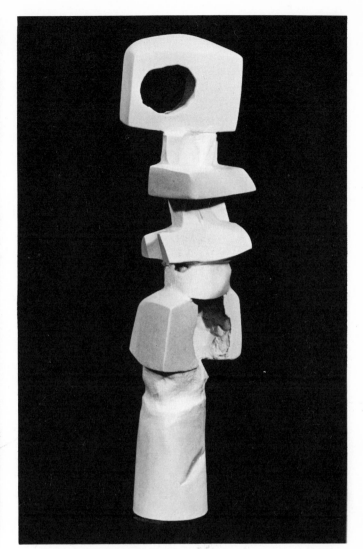

44. **CARESS** *Student, Institute of Design, I.I.T., Chicago.*

45. **ASSEMBLED STATUE** *Student, Institute of Design, I.I.T., Chicago.*

44.—Round forms and a tube shape, which resulted from pouring plaster into cardboard molds, formed the basis for this sculpture. The individual pieces of plaster may be placed together permanently and more plaster added to fill in cracks.

45.—These shapes seem to be precariously perched atop one another. Yet all the individual shapes seem to work together to form a unified whole. One views the entire sculpture rather than the parts of which it is composed.

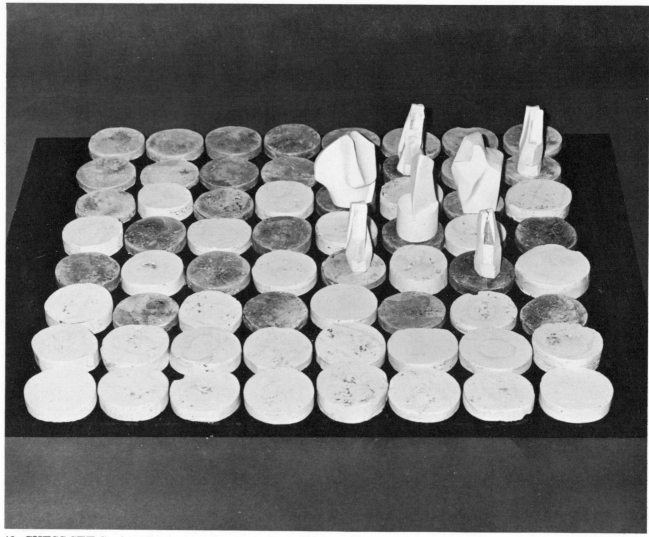

46. CHESS SET *Student, Institute of Design, I.I.T., Chicago.*

46.—Individual rounds of plaster were molded in cup bottoms, then smoothed and colored to form the chess board. The chessmen were carved from larger pieces of plaster, also poured into paper cups then carved. Each chessman is carefully designed, but the entire set becomes a unit that is artistically achieved.

47.—Egg-cartons cut apart and their various shapes rearranged can be the mold for a variety of sculptures. First, the parts of the carton are glued together, then carefully waxed, before pouring the plaster into them. The carton is destroyed after it is removed from the casting, but these figures demonstrate the principle.

48.—Instead of pouring the plaster into one large egg-carton form, the student made several molds. Each layer was made separately, then placed one on top of another and assembled. The shapes and relationships possible with this simple technique are infinite.

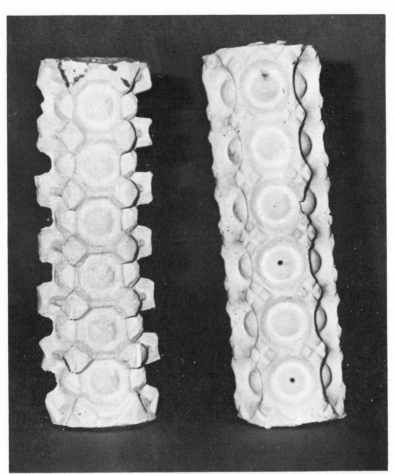

47. **EGG CARTON TOWER** *Student, Institute of Design, I.I.T., Chicago.*

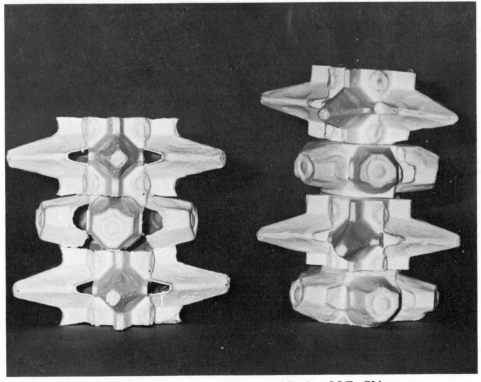

48. **PLASTER STRUCTURE** *Student, Institute of Design, I.I.T., Chicago.*

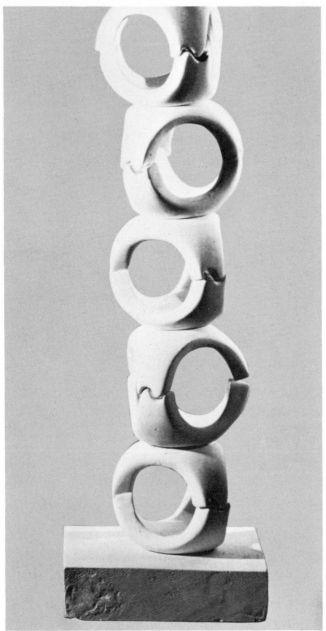

49. DESIGN 1 *Student, Institute of Design, I.I.T., Chicago.*

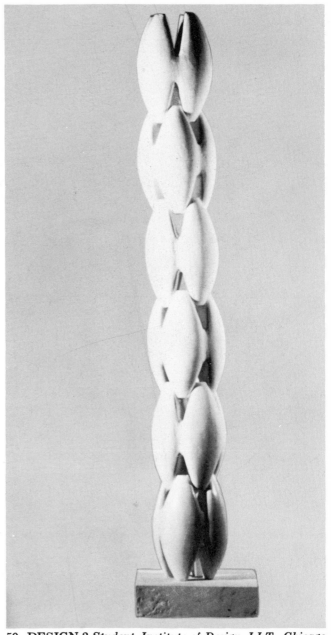

50. DESIGN 2 *Student, Institute of Design, I.I.T., Chicago.*

49.—By repeating one design motif and arranging it in a symmetry, a beautiful sculpture results that utilizes space within the negative areas. The smooth surfaces add to the simple loveliness of the sculpture.

50.—It takes great patience to create forms that interlock and relate as well as these do. These sculptures illustrate some of the projects possible with the assembling technique.

51.—The repeated oval shapes and the clawlike projections are smoothed so carefully that the piece appears to have been finished by a machine. From this model, the artist had a bronze sculpture made, although the plaster model can be a finished piece in its own right.

52.—Archipenko was an early contemporary sculptor who used plaster to create a finished work. This piece, of colorfully-painted round shapes, was a departure from the cubist sculpture being done in Paris in the early 1900's.

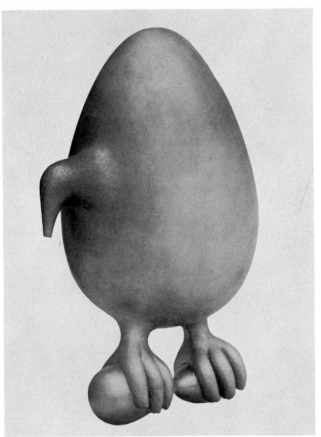

51. GREAT PEACE SYMBOL *Cosmo Campoli.*
Courtesy, Allen Frumkin Gallery, Chicago.

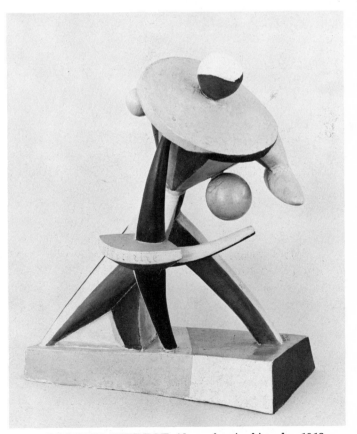

52. CARROUSEL PIERROT *Alexander Archipenko. 1913.*
Courtesy, The Solomon R. Guggenheim Museum, New York.

SCULPTING FROM A BLOCK

You have seen how a form can be made by casting it into a negative mold. If you pour plaster into a box, sphere, cone, pan or other container you will have cast a solid piece of plaster. This cast, like a piece of stone or marble, can be carved into an unending assortment of shapes and designs.

Waxed milk-cartons are sturdy and pre-waxed, so are very satisfactory for making the sculpting block. Other containers should be coated with a separating medium. Tap the table gently as you pour so that the plaster will fill the container well and eliminate air pockets and bubbles.

When the plaster is set (it does not have to be thoroughly dry), peel away the container. Draw your design on the plaster to help visualize where the grooves and shapes will be. It is a good idea to "sketch" the form first in clay or to work out your design on paper, which gives you an opportunity to revise the sculpture before carving the plaster.

As you carve the block, you are subtracting material; hence, the subtractive method is being used. The sculpture should be creatively designed to appear rhythmic and orderly from all sides.

53.—These sculptures by eighth-grade students were poured into waxed cartons of different sizes. Knives, sandpaper, spoons and other simple tools were used for carving, and this variety of shapes resulted.

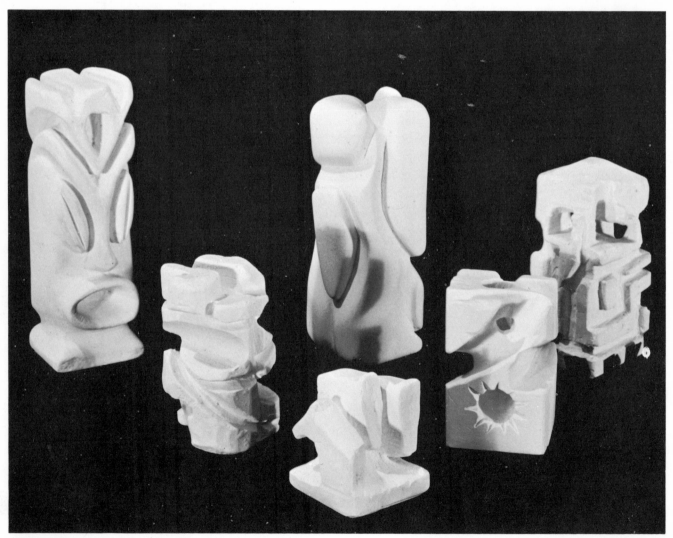

53. BLOCK SCULPTURES *Eighth-grade students*

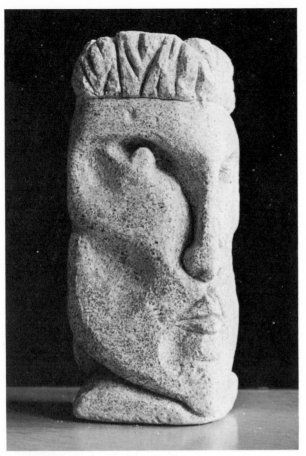

54. HEAD *High school student*

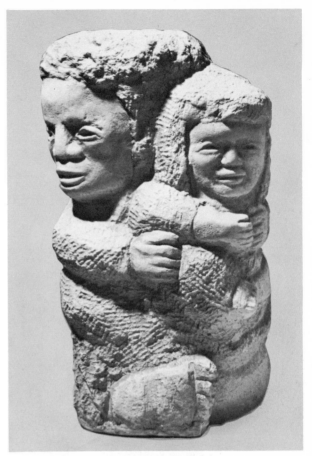

55. MOTHER AND CHILD *Si Gordon*

54.—Vermiculite added to the plaster mixture gives the material a texture. It also makes the block lighter in weight and easier to carve. (*See* Technical Notes, Chapter 6, for proportions and other materials that may be added to the mix.)

55.—This well-designed, closed sculpture carved from a block has a repetition of shapes and textures. The smoothness of the hands and faces contrast with the roughness of the hair and bodies. Texture was obtained by working the damp surface with sharp tools.

56.—The texture in this block also was created by adding vermiculite to the wet plaster. The outline of the form is sketched, and carving progresses by using simple knives and a melon baller for scraping. The rubber mallet helps to exert more pressure on an instrument.

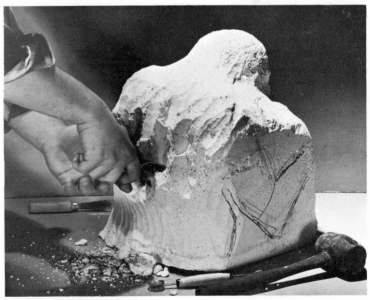

56. Carving from a block

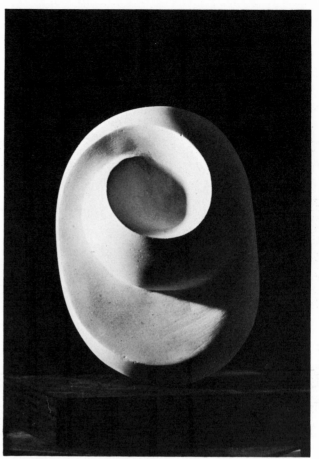

58. **FREE FORM** *Sister Mary Bonita, R.S.M.,*
St. Xavier College, Chicago.

57.—The sensitive forms have been smoothly finished. They relate to one another yet contrast in size, shape and design.

58.—The swirling curves created in plaster attest to the movement that can be achieved with such a solid material.

59.—There are hundreds of different textures that can be mixed with or applied to plaster. Here, paint was splattered on the finished figure to give the mottled effect.

60.—By painting the figure black, the artist achieves a metallic finish.

61.—A copper patina was applied to the plaster in this statement of a scene depicting a historical moment.

62.—The plaster may be left in its original white state, and the beauty achieved by the starkness of tone and modeling, as well as design.

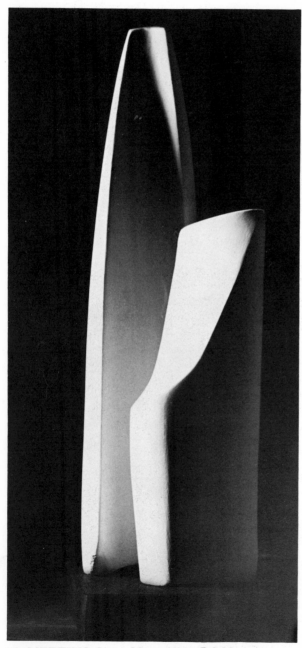

57. **MEETING** *Sister Mary Aline, R.S.M.,*
St. Xavier College, Chicago.

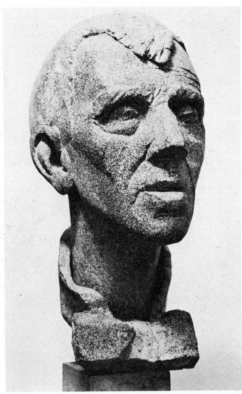

59. PORTRAIT OF POP HART *Reuben Nakian.*
Collection, The Museum of Modern Art, New York.

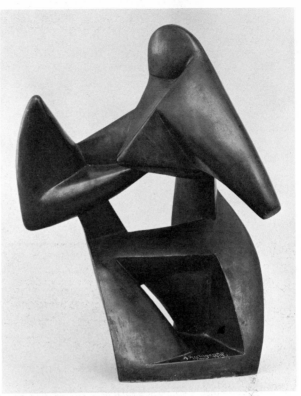

60. STRUGGLE *Alexander Archipenko.*
Courtesy, The Solomon R. Guggenheim Museum, New York.

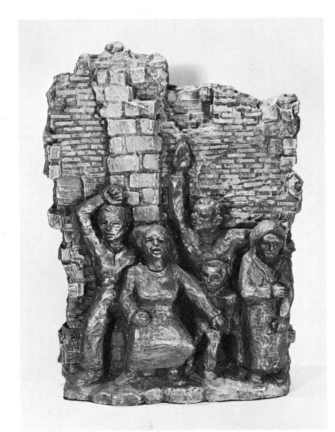

61. WARSAW WALL *Si Gordon*

62. UNTITLED FORM *Sister Mary Linai,*
St. Xavier College, Chicago.

63. DESIGN FOR A COIN *Richard Lippold. Courtesy, ART IN AMERICA Magazine.*

64. TENSION *Student, School of the Art Institute of Chicago.*

63.—When several sculptors were asked to design a coin, Richard Lippold executed his model in plaster. This partially sculpted model is an excellent illustration of the working method of the artist. After modeling a circular form, the carved edge was created. The geometric design, first worked out on paper, was transferred to the plaster block and portions were carefully sculpted.

64.—To simplify digging and scraping, random shapes of plasticene clay were placed inside the milk carton before the plaster was poured. After the plaster set the carton was peeled away, the clay was dug out and negative areas remained. Further gouging and scraping made the surface texture varied and interesting. The damp block was painted with temperas, and, as the color was absorbed by the plaster, a variety of delicate hues resulted.

BUILDING ON AN ARMATURE

An "armature" is a supporting device for sculpture material such as plaster and clay. Wire, plastic, twigs, cardboard tubes, clothespins, Styrofoam, balloons, excelsior and papier-mache can all be used successfully for the base, or armature, of shapes made of plaster.

An armature gives strength to the plaster. It enables one to build structures that would be impossible to make from plaster alone. The armature permits the plaster to dry more readily because the form is more hollow than solid. For large pieces of sculpture, an armature is essential because of the drying. It also makes the finished piece lighter in weight and stronger.

Wire screening, cardboard or any material that can be fashioned into a framework may be used as the core for a large plaster figure. If the plaster will not adhere directly to the armature, dip rags in plaster and wrap them around the form to build up the shape. The rags remain on the form and become part of the sculpture, although they are not visible in the finished piece.

For small sculptures, armature wire in several thicknesses and weights is available. It is soft and easy to bend. Wire hangers also may be used but are more difficult to bend.

65.—An armature of wire had to be used to support these thin columns of plaster that stand 65½ inches high. Strips of cloth dipped in plaster were wrapped about the armature. Without the wire support, such a column would be brittle and easily broken. Even a shorter column would be very fragile.

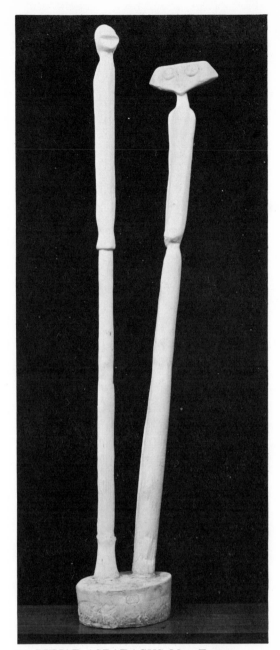

65. LUNAR ASPARAGUS *Max Ernst.*
Collection, The Museum of Modern Art, New York.

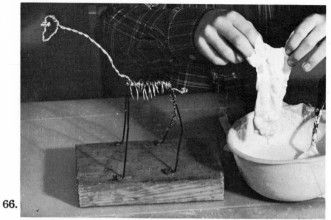

66.

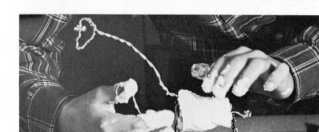

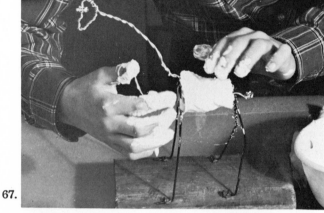

67.

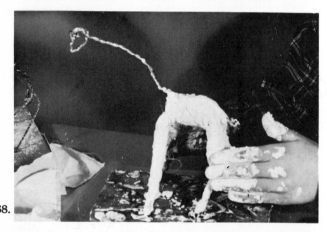

68.

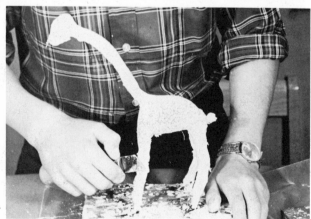

69.

66.—This giraffe, by a first-year high school student, illustrates the method of building up a plaster sculpture on an armature. First, a sketch showing the gesture of the animal was made from pipe cleaners, then transposed into wire. Hanger wire was used for legs and feet which carried the weight of the figure. The feet were nailed or stapled to the wood base. Soft armature wire was wound around the body and used for the neck and head. Small strips of rag were dipped into plaster. (Mix only small amounts of plaster at a time since it dries quickly.)

67.—The plaster-dipped rags were wrapped around the armature and shaped. More wet plaster can be applied where necessary to fill out areas. Notice how thin wire was wrapped around the rear leg. This helps provide a better grip for the plaster to adhere to the smooth hanger wire, and prevents the rag from sliding before the plaster sets.

68.—The student continued to build up the shape with the plaster-saturated rags, always modeling the plaster in the general shape of the animal.

69.—After plaster has set slightly, refining may be done by carving, scraping or sanding the form. A wet sponge rubbed over the plaster will help keep it moist, make carving easier and smooth the surface.

70.—The finished figure was painted with temperas; a fringe of yarn was glued on for the mane.

71.—Rags dipped in plaster were also used over a wire armature to create this figure. The "hair" was applied simply by adding fingers full of plaster and modeling it.

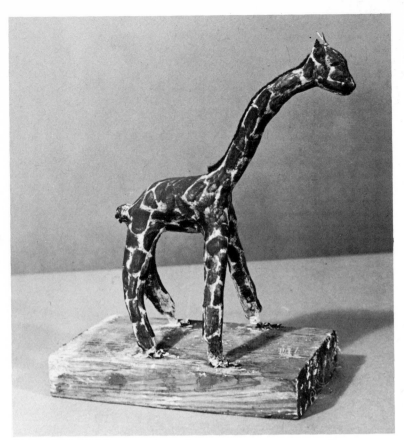

70. GIRAFFE *Ninth-grade student*

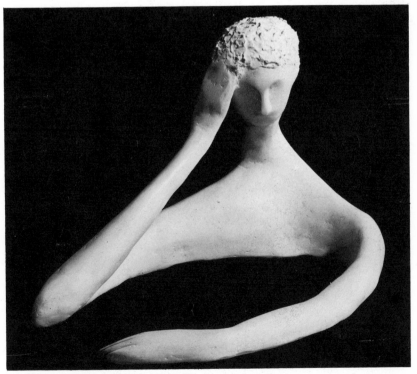

71. GIRL WITH LONG ARMS *High-school student*

34

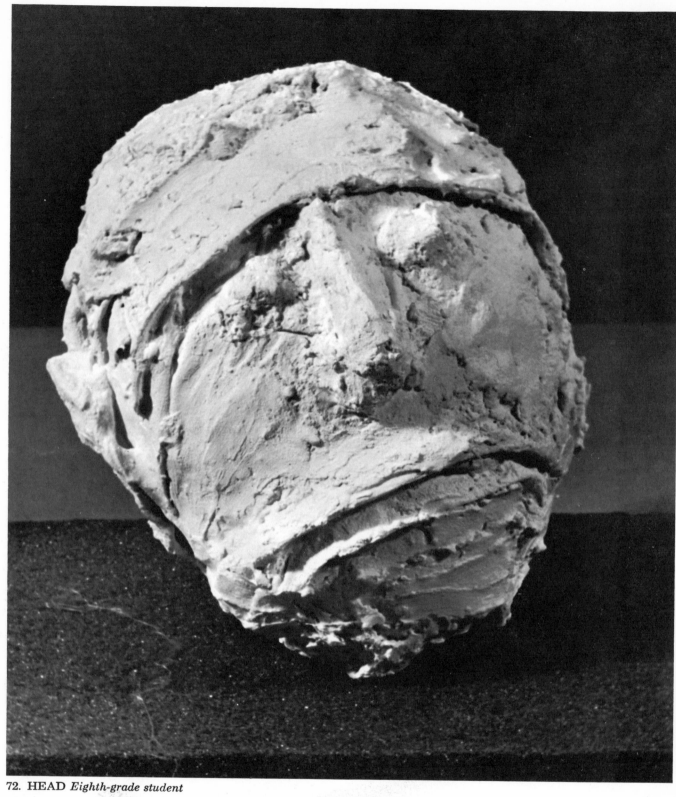

72. HEAD *Eighth-grade student*

72.—A balloon formed the armature, or basis, for this expressive head, created only from rags saturated in plaster, as shown in the demonstration.

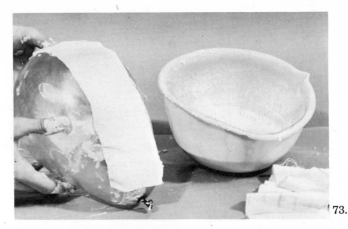

73.

73.—The balloon, the size and shape of a head, is inflated then covered with one layer of plaster-saturated rags. These harden and assume the round shape of the balloon armature.

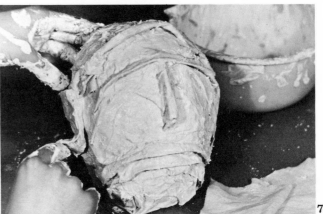

74.

74.—Additional plaster-dipped rags are shaped to form the protrusions of nose and ears, the folds of brows, hairline and mouth. Later, eyes were added. Wet plaster was applied directly in some areas to cover up the edges of the rags, and a solid-looking sculpture remained. A hole was left at the back of the head so that the balloon could be punctured after the plaster set, permitting the piece to dry evenly. Balloons of various shapes are also good bases for creating replicas of the earth and planets.

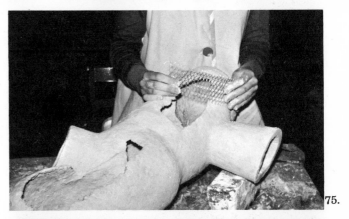

75.

75.—Here, heavy mesh screen wire is used for the armature. This sculpture is made of concrete and will be placed outdoors.

76.—Instead of rags, hemp dipped in plaster is placed over an armature made of chicken wire. The finished surface will be highly textured and very strong because of the mixture of hemp fibres and plaster.

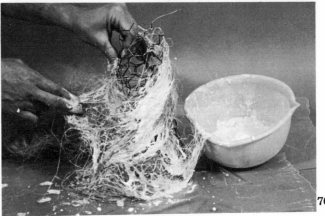

76.

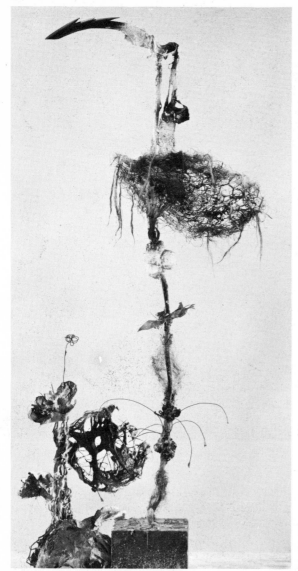

77. FRAGMENTS OF A WASTELAND *Don Seiden.*

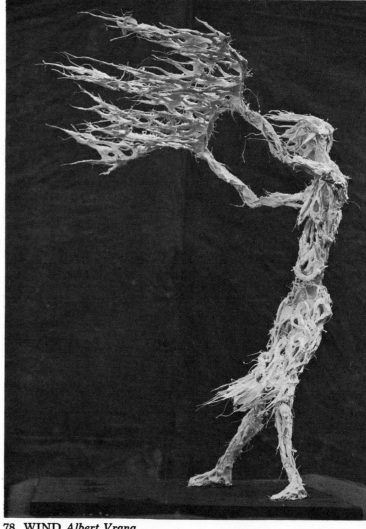

78. WIND *Albert Vrana*

77.—The armature in this open, airy sculpture becomes an important part of the composition. Chicken wire and other protrusions are attached to the main wire armature by either bending or wiring.

78.—Hemp and plaster combine in this figure that looks as though it would wave in the wind. Because of the strength of hemp, the plaster can be given almost gravity-defying forms. The negative shapes are as important as the positive areas.

79.—This sculpture presents a solid, closed form. It exists in space rather than having space become a part of its interior composition. This piece, which stands 7½ feet high, is built over an armature. The finished appearance is as permanent as though it were made from stone.

80.—A thin or thick, quiet or moving feeling can be achieved. The armature holds the figure which could not be formed otherwise.

81.—A curving, thin, mobile design has been built up over a wire frame on which plaster-dipped rags were applied. Despite the wire and rags, the finished piece has been smoothed and looks as though it were solid plaster.

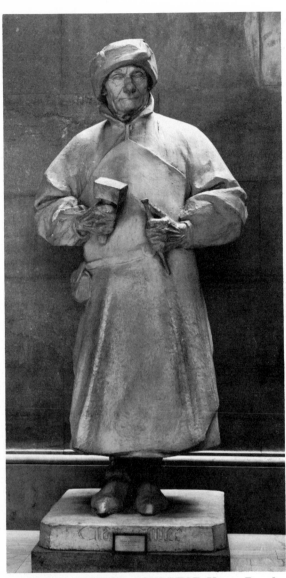

79. CLAUS SLUTER, SCULPTOR *Henry Bouchard.*
Courtesy, Art Institute of Chicago.

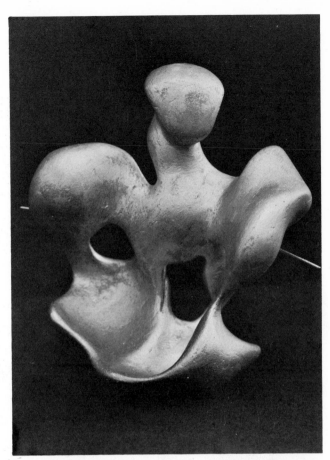

80. CONSTRUCTION WITHIN A SPHERE *Georges Vantongerloo.*
Collection, The Museum of Modern Art, New York.

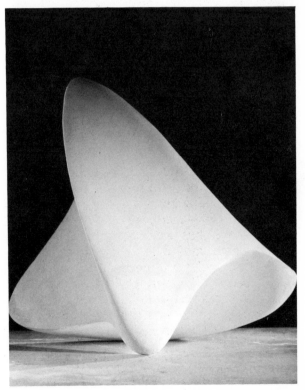

81. UNTITLED *Sister Mary Linae, St. Xavier College, Chicago.*

38

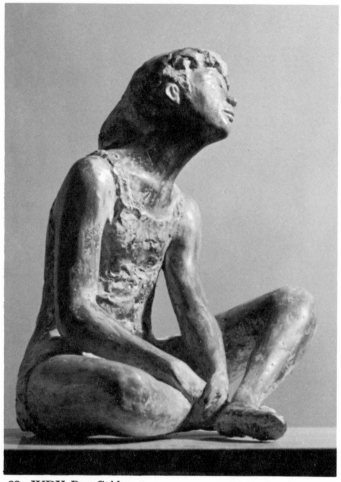

82.—A finished plaster sculpture built over an armature has the appearance of finely carved stone. All the talents of an accomplished sculptor were required to create this figure that is realistic, relaxed and beautifully designed when viewed from all sides. The material was toned with paint to simulate stone.

83.—Bamboo and string became the support material, or armature, for this model for a bridge, later transferred into architectural reality.

84.—The heavy wire armature for this dynamic figure included extra wires suspended from the horizontal wire arms; hemp was used as the fabric base. The result is strong, durable and artistically envisioned.

85.—A piece of driftwood, wire and hemp were used for the base of this organic form. Plaster may be used in combination with many materials.

82. JUDY *Don Seiden*

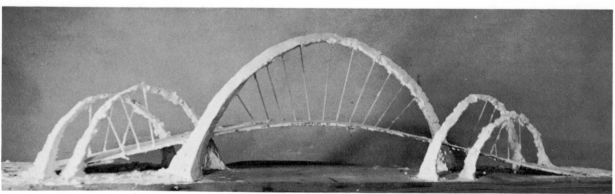

83. MODEL FOR A BRIDGE *Albert Vrana*

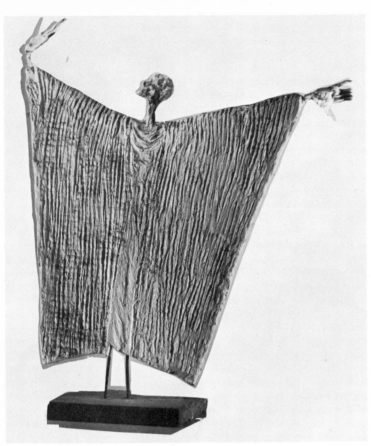

84. THE PROPHET *Si Gordon*

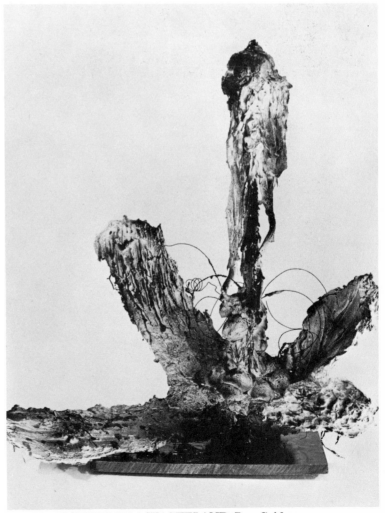

85. FRAGMENTS OF A WASTELAND *Don Seiden*

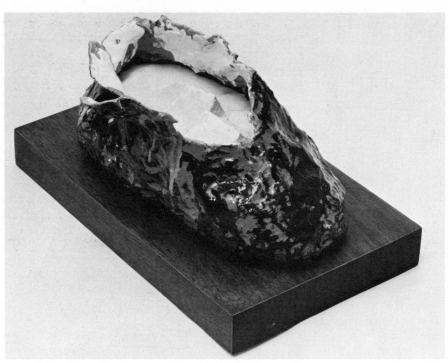

86. BIG BAKED POTATO *Claes Oldenburg. Courtesy, Sidney Janis Gallery, New York.*

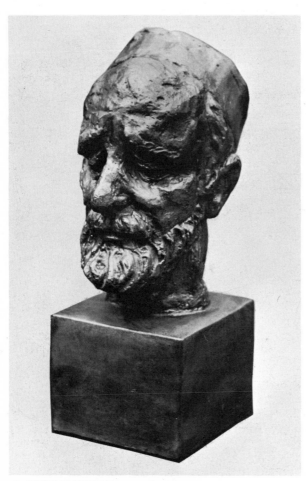

86.—Plaster and muslin make up this unusual piece of Pop art, by a master of the twentieth-century art movement. A coat of paint gives the outside its realistic appearance, while the white of the plaster simulates the inside of the potato.

87.—Grey hydrocal, worked with rags over a screen wire form, was used for this sensitive protrayal of a rabbi. An infinite range of textures can be obtained with these simple materials.

88.—A concrete wall with pieces of stained glass in the negative areas illustrates the versatility of the materials in architectural usage. The result is a wedding between the arts of the sculptor and the architect.

89. Cement plaster over lath was used for the seven undulating bays in this dramatically simple and beautiful church interior in Washington, D.C.

87. THE RABBI *Immergluck*

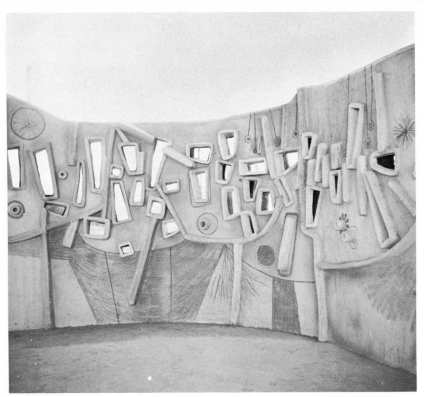

88. SCULPTURED WALL *Don Drumm*

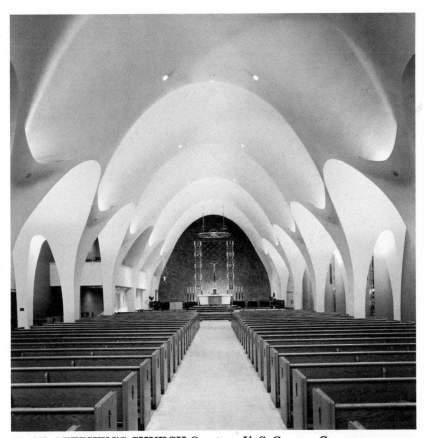

89. ST. STEPHEN'S CHURCH *Courtesy, U. S. Gypsum Company.*

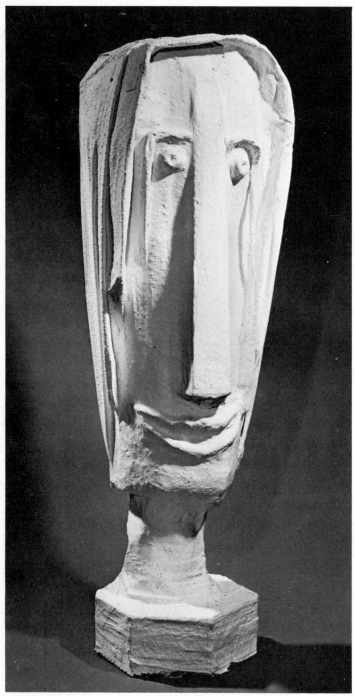

90. **LADY WITH DUST CAP** *Courtesy, Pariscraft.*

90.—Pariscraft is a fabric already impregnated with plaster. It requires only a dousing in water to make it workable. The procedure of mixing plaster is eliminated, leaving no messy cleanup afterward. Pariscraft works extremely well over balloons and cardboard tubes. For bulkier shapes an armature of cardboard boxes, oatmeal containers, or almost anything you can devise, will work well.

In "Lady With Dust Cap," Pariscraft is built up on a cardboard-tube armature. You can continue to build out your form by applying layers of the plaster-coated fabric, creating folds for the eyes, cap and mouth, and building out the nose.

91.—A balloon was used as the base for the octopus; a detergent bottle is the base for the pig. The bases lose their identity as artistic vision takes over. Plastic detergent bottles covered with plaster and decorated may also be used for flower vases.

92.—To use Pariscraft, simply cut off a piece of the dry material from the roll and moisten it in water so that it has a plaster-like consistency.

93.—Build up the shapes by covering the armature or base with several layers of the material.

94.—The form may be painted with water colors, temperas or any other paint product. It can be painted when damp or completely dry for different effects.

91. THE OCTOPUS AND THE PIG *Courtesy, Pariscraft.*

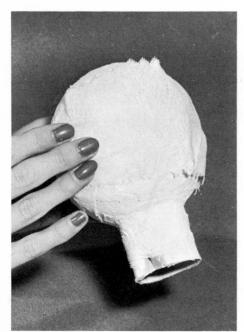

92. Dipping

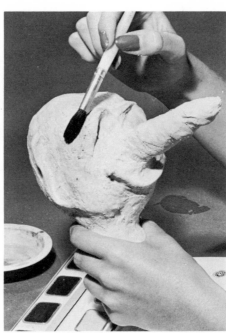

93. Wrapping

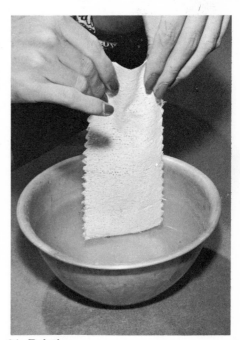

94. Painting

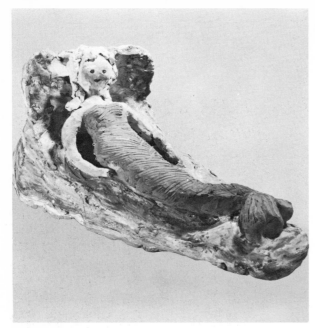

95. MERMAID *Student,*
School of the Art Institute of Chicago.

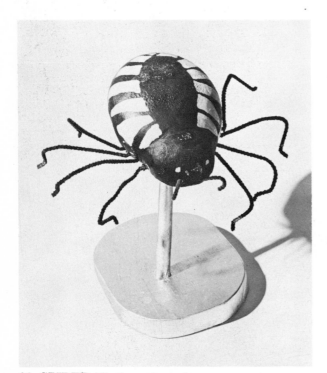

96. SPIDER *Ninth-grade student*

95.—A cardboard box, crushed and shaped, was the base for this young girl's version of a mermaid. It was finished with tempera paints.

96.—Papier-mâché is a good foundation for a plaster sculpture. Mâché is made by dipping strips of moistened newspaper into a glue or paste. Plaster is worked over the mâché and smoothed and painted. Pipe cleaners form the legs.

97.—Styrofoam balls are covered with plaster to create the texture and features for these puppets' heads. Clothes are made from scrap material and cover the bodies, which are actually the children's hands. A papier-mâché ball can also be the base for a puppet head.

98.—Pariscraft is applied over oatmeal boxes placed at 45 degree angles. One becomes the head, the other the body. Some of the fabric texture suggests the horse's bridle.

99.—A twig and string covered with plaster and set in a Styrofoam base become a beautiful open abstract sculpture.

100.—Toothpicks glued together, then dipped in plaster, may be used for sculptures or hanging mobiles. Gluing should be done on waxed paper so that the joints adhere well and do not stick to the paper. The sculptures may be spray-painted, dipped in paint or dabbed with a brush.

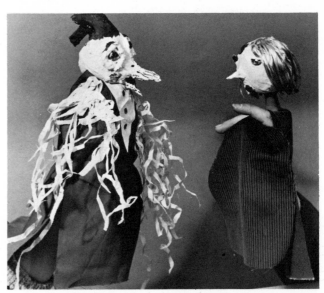

97. PUPPETS *Eighth-grade students*

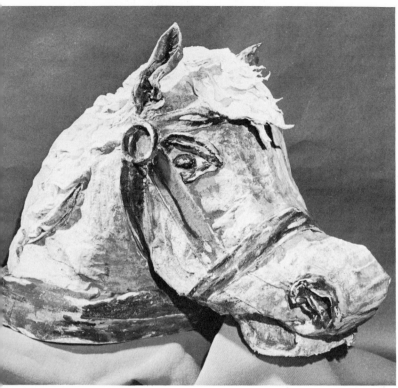

. HORSE *Courtesy, Pariscraft.*

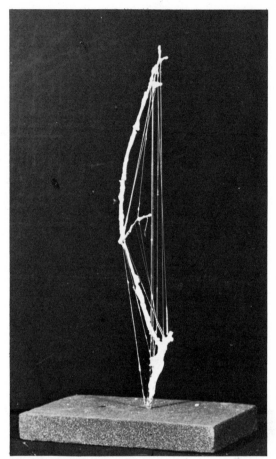

99. STABILE *Dona Meilach*

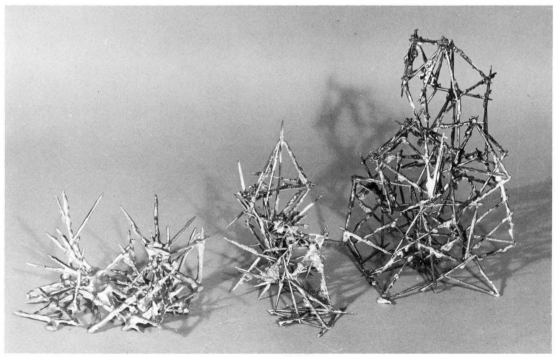

100. TOOTHPICK SCULPTURES *Eighth-grade students*

46

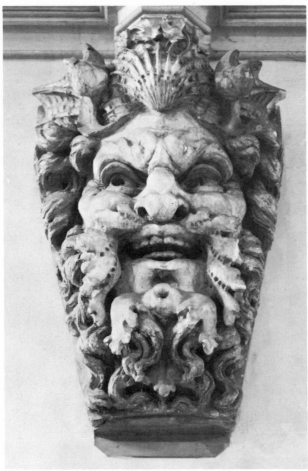

101. FIGURE FOR ARCHITECTURE *Auguste Rodin. Courtesy, Musee Rodin and S.P.A.D.E.M., Paris.*

RELIEF SCULPTURE

A "relief" sculpture consists of figures or designs that stand out and away from the background to which they are attached. (Sculpture "in the round" is three-dimensional and may be viewed from all sides.) A relief design is two-dimensional and intended to be viewed from the front only. However, the third dimension is suggested.

The relief form may be part of an architectural decor. The technique dates back thousands of years. The classic example is the ornamentation of the frieze near the top of the Parthenon in Athens. Relief is popular for plaques, wall treatments and hanging decorations.

Reliefs are of three kinds: high relief, in which the figures project boldly; low or bas-relief, in which they project slightly; and intaglio, in which the figures are sunk into the background.

Line, light and shade are the organizing elements of a relief sculpture. The raised areas are purposely created to catch light. The sunken areas hold shadows which become an integral part of the composition.

Traditionally, the artist makes a relief surface by two basic methods: direct surface treatment and casting. For direct relief, he may begin with a solid piece of material such as stone, marble, wood or plaster. He draws his design, then begins cutting into the material in such a way that the figures project and give an illusion of depth. He may use sharp angles, rounded-off edges or deep undercuts, all in one relief design, so that the lines and shadows are varied.

You are already familiar with the casting method. The relief form results from pouring the liquid medium into a negative mold made of clay, sand, Styrofoam or other material. Castings are considered indirect relief because they are formed from a mold. Sometimes both methods are combined. The artist begins with a casting, then further carves and models the work.

Relief designs are made by other methods, also. The artist may apply plaster to a surface and model it before it dries. He may also achieve the protruding surface effect by embedding any variety of found objects into the plaster medium. The objects then stand away and form the relief.

101.—Rodin usually worked directly in plaster, whether he made figures in the round or architectural decorations, such as this figure done in the late 1800's.

102.—Early English architecture was extremely ornate and rococo. Plaster was used to create the decorations in the interiors of formal dining rooms, such as this one from about 1765, in London, England.

103.—Today, plaster is still a popular decorative material, but in a contemporary statement. Applied plaster forms high relief and low relief, which are combined to produce a contrast of shape, design and interest.

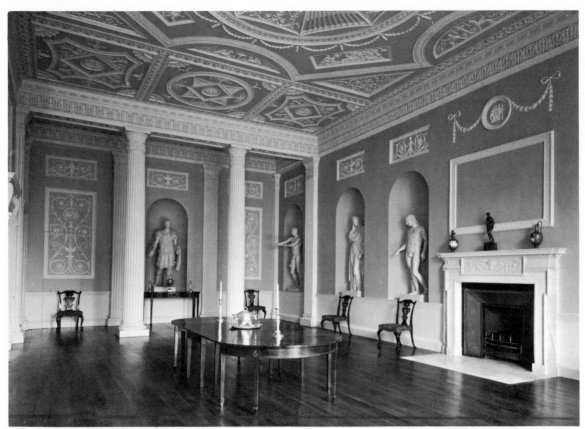

102. PLASTER DECORATION *Courtesy, Metropolitan Museum of Art, New York.*

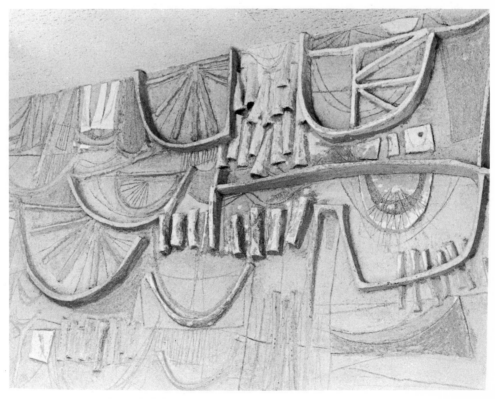

103. WALL RELIEF DETAIL *Don Drumm.*

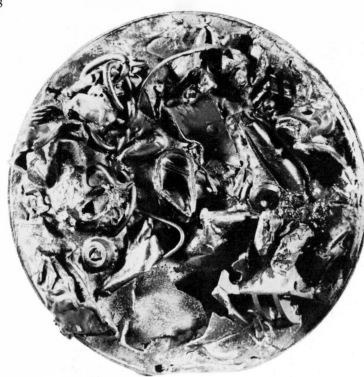

104. OFFERING *Harry Bouras*

104.—Because of its versatility, strength and holding power, plaster is used for many relief effects. Here it is used for embedding found objects. The plaster is spread on a surface and the objects arranged so that they twist and attain different levels. The entire piece is painted black and simulates iron, even where the plaster surface exists.

When plaster is used for embedding, a backing surface that contains some porosity is best, so that the plaster crystals can dig in and hold. If a smooth surface is used, the plaster will tend to chip and crack in time. Any surface less than ½ inch thick will eventually warp and buckle, causing the plaster to crack.

Gypsum-board and wallboard make the best backings because they are covered with a material that dissolves when the plaster is placed on it. The material then forms a bond with the plaster. Porous wood such as the unfinished side of plywood is satisfactory. If solid woods are used, they should be scratched and gouged to form a toothed surface for the plaster to grip.

105.—Wood and plaster shapes are combined in this painted relief composition.

106.—Pieces of threaded pipe were used as a mold, and many duplicate shapes of pipelike plaster resulted. They were fragmented and embedded in plaster, then painted black. The lights and shadows caused by the objects placed at various levels are typical and an important aspect of the relief sculpture.

107.—A pattern from a plastic carseat-cover provided the mold for the pieces of plaster embedded in a plaster slab. Broken pieces of windshield glass were arranged with the pieces of plaster.

108.—Plaster will hold all types of mosaics and other stones and become the "grout," without the necessity of additional material between the stones.

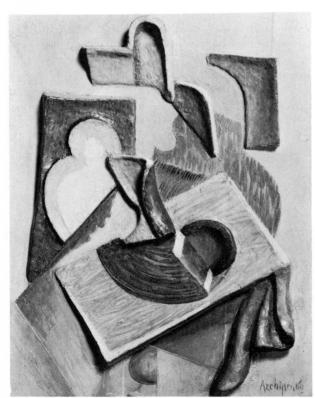

105. **GLASS ON A TABLE** *Alexander Archipenko. Collection, The Museum of Modern Art, New York, Catherine S. Dreier Bequest.*

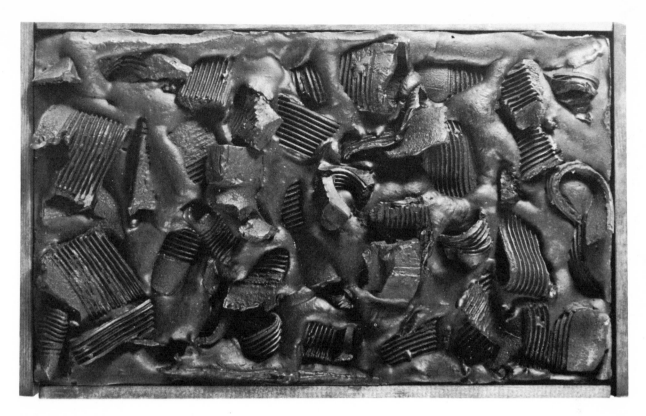

106. STAR'S SEASON *Harry Bouras*

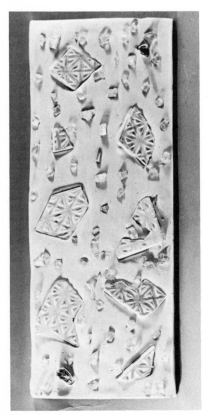

107. PLASTER, GLASS & PLASTIC *Eighth-grade student*

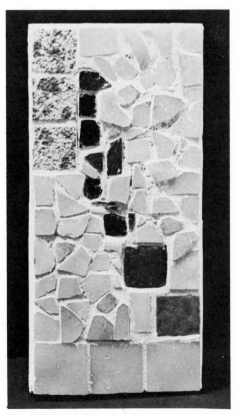

108. MOSAIC *Harriet Arenson*

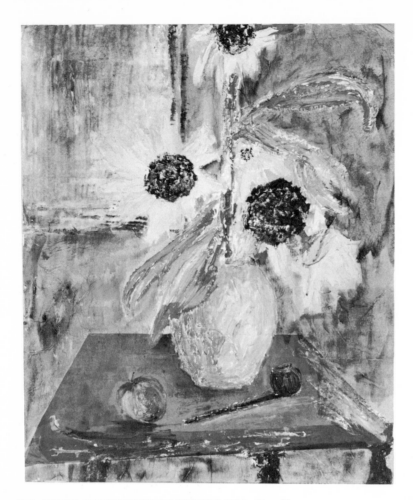

109. STILL LIFE WITH FLOWERS *Elvie Ten Hoor*

110. Painting the relief flower

111. Embedding

109.—This colorful relief design was created by using modeling paste, a plaster-like substance already in a prepared consistency, for building up portions on a background. The paste is spread directly on the canvas and modeled to the desired form. Paint and colored tissues were applied on both the flat areas of the canvas and the relief areas.

110.—The flower relief areas were created with the modeling paste, then painted. Plaster and cement may be used the same way.

111.—For embedding, spread plaster on a backing that has been gouged and scraped so the plaster will adhere without cracking. Then place the objects in the wet plaster. When planning such a project, it is a wise practice to lay the objects out on a piece of paper first, so that you determine your design before embedding. Once an object is embedded in the plaster it may be removed, but it leaves a broken surface which may be difficult to revise.

112.—Found objects of scrap metal are placed in a frame of wood to symbolize the contents of the earth at different stratifications. Sometimes, to repeat a motif or object, Bouras makes a plaster cast of an object, then paints it black so that it appears just as metallic as the original fragment. (*See* "Duplicating with Plaster," page 62, for the technique of making a plaster mold from which a duplicate object can be cast.)

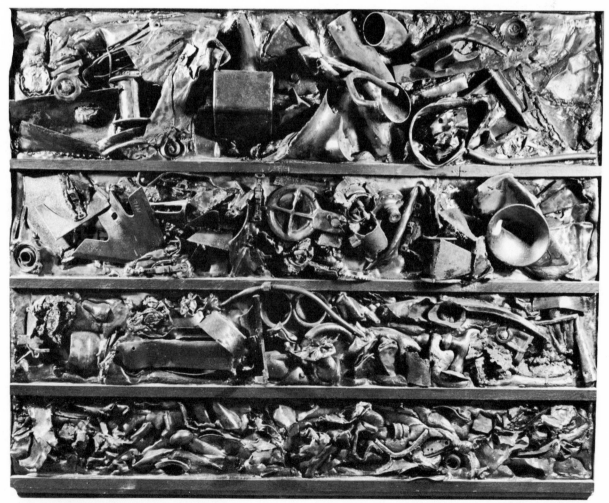

112. **DIFFERENT STRATA** *Harry Bouras*

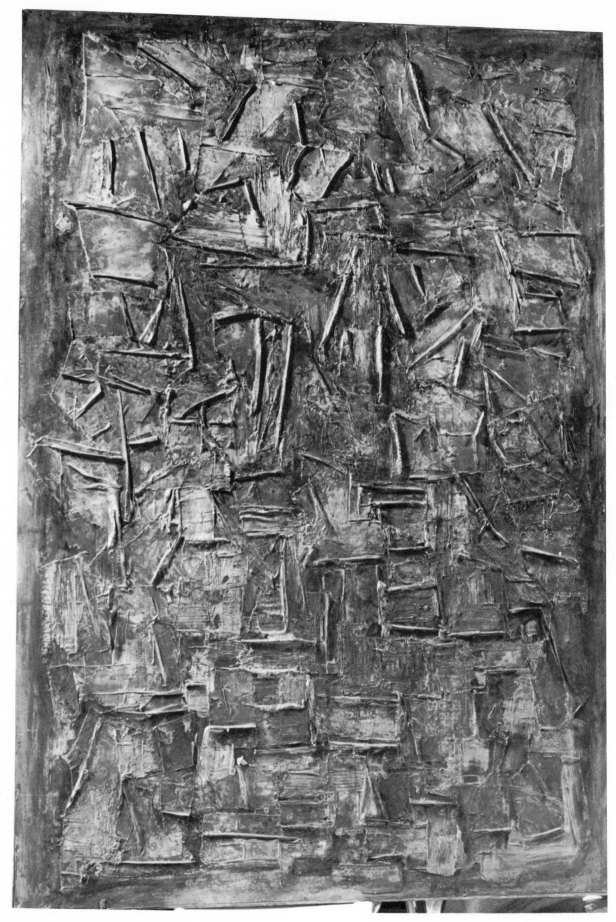

113. **COLUMBIAN ASPECT** *Harry Bouras*

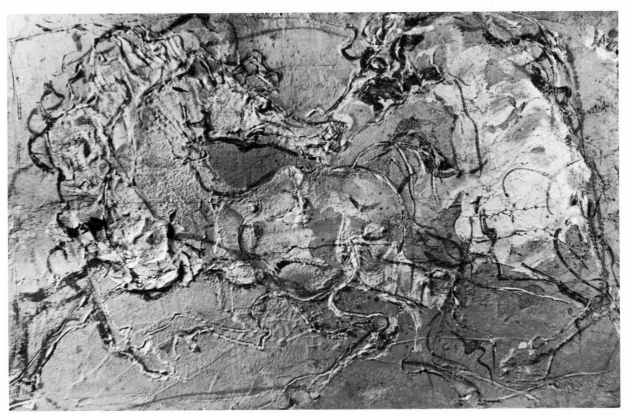

114. HORSES *Pietro Hazzari. Collection, Harry Bouras*

113.—A backing surface was painted, then linen dipped in plaster was applied to the surface, so that there would be flat areas and ridges. The texture of the linen and its raw edges were used. The plaster makes the ridges extremely hard. The entire surface was painted in rich browns.

114.—Plaster was applied to a gypsum-board backing, much as oil paints are applied to a canvas. Portions of the surface are flat and smooth while other areas stand out in low relief. The entire work was finished by painting with oils.

115.—Found objects, including a piece of an old license plate and a jar cap, were embedded in plaster to suggest the structure beneath the earth's surface.

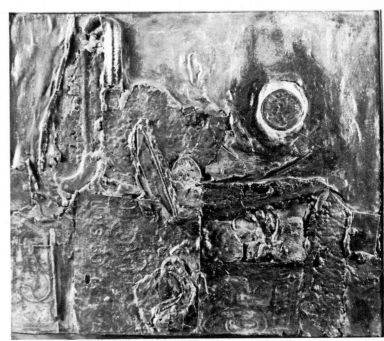

115. LAND FIGURE *Harry Bouras*

116. SPATIAL ABSTRACT *Eve Garrison*

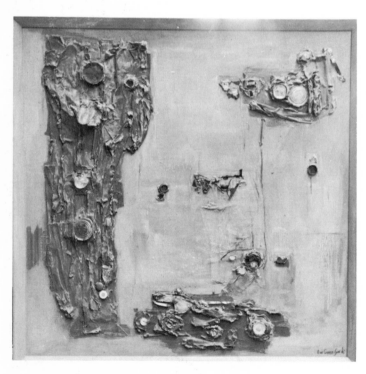

117. GOLDEN IDOL *Eve Garrison*

116.—A relief surface is built up on masonite with plaster or a similar medium that will harden. Newspapers are soaked in a mixture of Elmer's glue and water or Liquitex medium, then applied over the plaster. Some areas are left relatively flat; other areas have a texture combed or scraped into them. Still others appear as ridges and peaks.

117.—The plaster is shaped on the masonite backing and supplies both the large areas of the composition and the adherent for the embedded materials of found objects. The objects stand out as repeated shapes of silver that tie the composition together. Color may be added to the plaster and masonite. These relief compositions are considered collages; they have a dynamic sculptured effect.

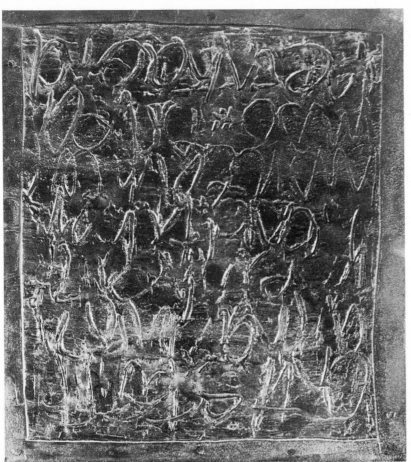

118. CALLIGRAPHY *Harry Bouras*

118., 119.—Bouras uses the ancient techniques of sgraffito and calligraphy in a contemporary manner. "Sgraffito" is a decoration produced by scratching through a surface layer of plaster and revealing a colored background beneath. First he colors wallboard with varnish or paint. Plaster (he often uses hydrocal) is placed on the board with a spatula and designed with thin lines. Some of the plaster is scraped when wet, so the background shows through. When dry, the plaster is further scraped, drilled and tooled away to bring out the design, which appears as low relief. The plaster is then stained the same color as the background. To create the pitted, bubbly texture, a small blow torch is used directly on the plaster and paint in various areas; then the surface is restained, in this case a rich mahogany. The technique of burning the surface is termed "pyrotage."

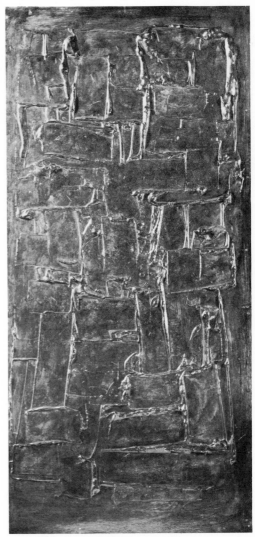

119. SGRAFFITO *Harry Bouras*

chapter 4
DUPLICATING WITH PLASTER

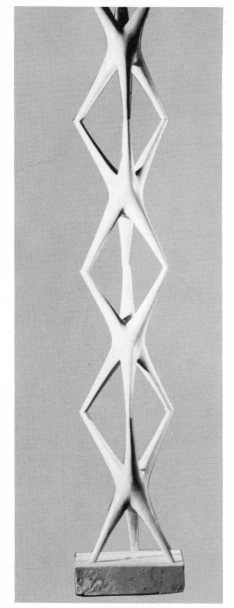

120. Design made by duplicating a model

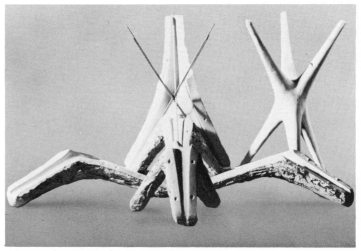

121. The piece mold used for the design

Often a sculptor wants to duplicate a clay or plaster figure by casting it into another more permanent material. To do this, he must create a plaster mold of the original piece into which a new material can be poured. There are two basic methods of duplicating—the piece mold and the waste mold.

THE PIECE MOLD

A piece mold consists of several small portions, planned so that each piece can be taken from the original, then put together somewhat like a jig-saw puzzle to make the mold for the new cast. Usually the piece mold is made from an original sketch model of clay or plaster. The new cast sculpture may be made of plaster, bronze or other metal.

The model must be carefully studied to determine where the sections will be made. Then one section at a time is outlined with plasticene clay as a "fence." The model is greased thoroughly with a separating medium. Plaster is poured into the clay fence and built up. Each section is made individually so it fits exactly against the section next to it.

122. Eight-piece plaster mold

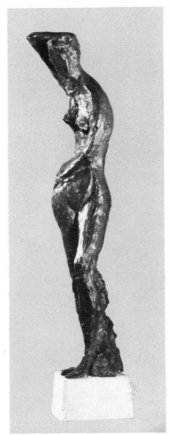

123. Bronze casting created from eight-piece mold *Albert Vrana*

All the mold pieces are then thoroughly greased inside and between each section, assembled and tied together. The cast material is poured into the mold through an opening left at the top and allowed to harden. Each piece of the mold is then carefully removed and the finished cast results. Usually the cast requires some trimming or smoothing around the seams.

120.—Many identical casts can be made from one piece mold used over and over. Here, the plaster casts are assembled to create a beautifully simple and open sculpture.

121.—The piece mold for these shapes consists of four parts. A supporting wire armature is set within the mold before pouring the plaster, to give the finished cast pieces extra strength.

122.—A clay model was the basis for this plaster piece mold. You can see how each individual piece was made, then assembled to become the negative areas for the finished cast. The mold should be quite thick so that it does not break with repeated usage.

123.—To recreate the clay model, the artist greased the mold, tied it together with burlap and left a hole at the top. Through this, liquid bronze was poured and allowed to harden, and this figure is the result. He also made several plaster casts which he patinaed to look like bronze.

THE WASTE MOLD

The waste mold is used when the sculptor wants to cast a clay model in plaster. He is not interested in saving the clay model, but wants the more permanent plaster replica. The waste mold is simpler to make than the piece mold. It is exactly what the name implies. In the process, both the plaster mold and the clay model are destroyed or "wasted." Only the perfect replica of the clay model, made of plaster, remains.

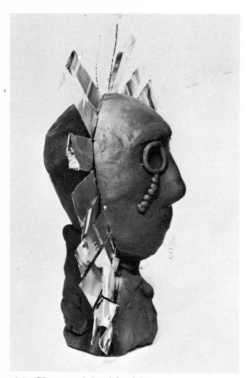

124. Clay model with shims

If you want to duplicate a head made of clay by the waste mold method you will need some 1- by 3-inch pieces of copper, aluminum foil or similar material to separate one half of the mold from the other. These are called "shims." Decide where your mold would most easily split in half, and insert the shims in the clay where the seam is to be, as shown (Fig. 124). The shims should protrude beyond the built up plaster.

Mix a small batch of plaster, using blue colored water, and apply a thin coat of the plaster over the entire clay model. (The blue color plaster is important later. It warns you that you are close to the cast when you begin to chip away the plaster mold.) Then add white plaster all around until you have built up the surface to at least a 2-inch thickness.

After the plaster has dried thoroughly, carefully separate the mold with a sharp instrument at the seam made by the shims. Dig out all the clay, and you will have a perfect negative of the clay figure in plaster. Leave a hole at one end of the mold.

Now grease the negative mold very well with a separating medium. Seal the seam and tie the mold together tightly with a rope or burlap dipped in plaster. Pour plaster into the mold, tapping it gently so the plaster flows into all the small areas and air bubbles are eliminated.

After the cast dries, remove the ties and begin to chip away the plaster mold carefully. When you reach the blue color you are close to the cast and must not chip too vigorously. If the mold was thoroughly greased, the pieces may fall away from the cast fairly easily unless there are small undercuts. When the mold has been chipped away the finished plaster cast will be exposed—an exact duplicate of the clay figure.

Making a waste mold takes practice; the beginner is wise to start with a small clay sculpture having broad planes and no intricate undercuts and protrusions.

125.—Plaster piece molds are used commercially for making many duplicate figures which are glazed or painted. The mold is first made from an original clay model.

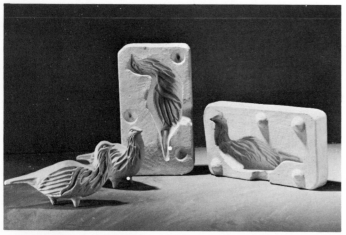

125. Commercial mold *Courtesy, Brech's Clay House, Hammond, Indiana.*

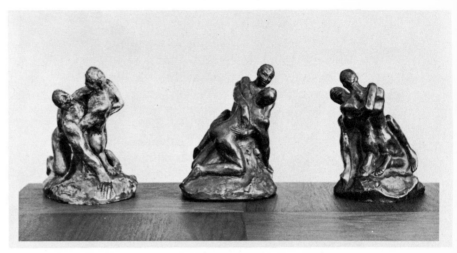

126. THE KISS *Auguste Rodin. Courtesy, Gulf Land Development Corp., Miami, Florida.*

126, 126a.—This dramatic working series —sketch, clay, plaster and bronze statue— by the master sculptor Rodin shows his method of developing a figure.

127, 127a.—This plaster figure with its negative areas and undercuts required several pieces for a mold. The bronze cast shapes were then assembled by foundry methods.

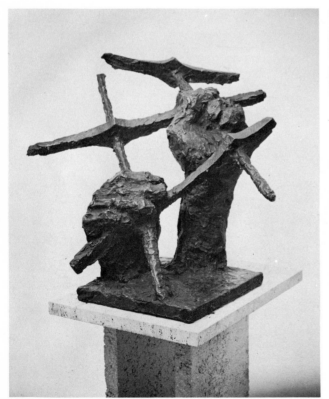

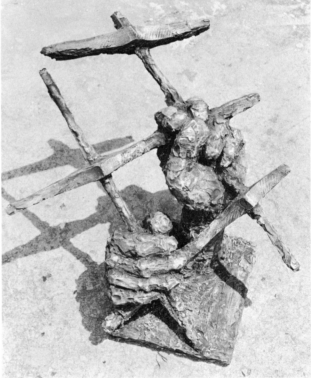

127. CAPTIVE *Albert Vrana*

chapter 5
PROJECTS FOR CHILDREN

Plaster may be used as a creative art material from the time a child enters kindergarten. The following projects are specifically suited to the primary- and elementary-grade student. Until about the seventh grade the teacher should be responsible for mixing the plaster, but after that most children can handle the mix without any trouble. For large batches (about a pailful) a slow-setting plaster is recommended. Then the teacher can dole out the necessary portions to the children. There will be ample time to work with the plaster before it begins to set. For some work, a quick-setting plaster will prove more efficient. Teachers are advised to try a few pounds of the different types of plaster (*See* "Technical Notes," Chapter 6) and then use that which best adapts to the particular needs.

In the classroom, disposable aluminum-foil pans, waxed-paper cups and cut-down milk cartons are excellent for mixing individual portions. Waxed paper or formica working-surfaces are easiest to clean up.

THE HAND PLAQUE

One of the first experiences primary-grade children enjoy is making hand prints in plaster. They get the feeling of plaster because they are directly involved in creating the design. They learn the difference between the negative and positive concept.

The child's hand should be thoroughly coated with vaseline. Pour plaster to about a three-fourths inch depth into an aluminum-foil pan. Tap the pan to help reduce air bubbles. The hand is placed in the plaster with the fingers separated and held still until the plaster begins to harden. (Use a fast setting plaster of Paris.) When the plaque dries, it may be decorated.

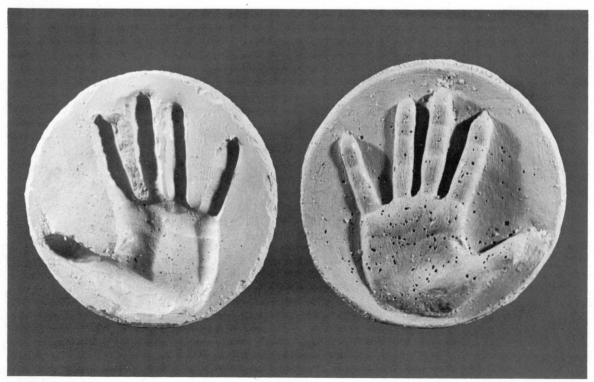

128. NEGATIVE AND POSITIVE HAND PLAQUE

Before decorating you can recreate the child's hand so that it is raised from the background as a "relief". Brush vaseline or other separating medium on the first mold. Brush it into all the indentations, on the top and the sides. Place the mold back into the aluminum-foil pan and press the sides of the pan as close as possible to the mold, to keep the new plaster from dripping down the sides. Pour another ¾ inch of plaster into the hand print. When the two molds are dry, separate them and you have both a negative and a positive hand plaque.

FREE FORM PROJECTS

Plastic-bag forms, among the many free form abstract projects, are easy to do in the classroom and involve only one or two art periods. The range of shapes is infinite.

129.—A plastic bag is partly filled with quick-setting plaster. Indentations are made with the fingers and the plaster is shaped with the hands, then held in one position until the plaster begins to set. Notice how the chemical reaction causes the plaster to become warm. After the plaster has set, put the form aside to dry overnight. Then peel away the plastic bag.

130.—Additional gouges and scrapes may be made to accentuate the pattern and evolve a better, more pleasing design. Ridges left by the bag may be sandpapered.

131.—The finished free form may be painted with a brush, sprayed or given other surface finish. A white enamel will give it a high gloss finish. It may be used as an attractive paperweight or shelf decoration.

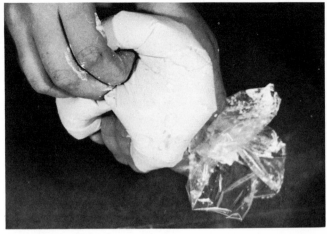

129. Holding the plaster

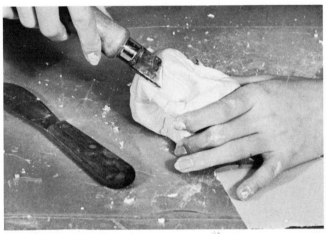

130. Gouging

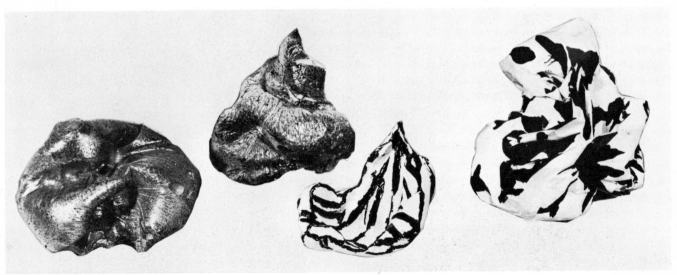

131. PAINTED FREE FORMS

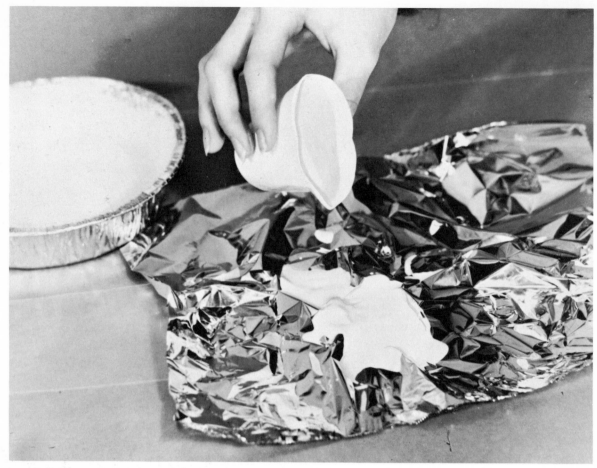

132. Free forms in aluminum foil

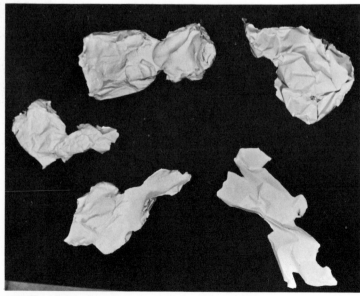

133. Resulting shapes

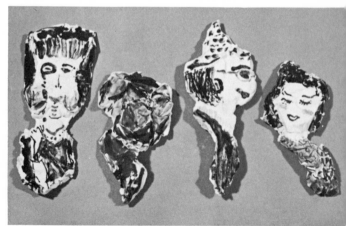

134. They take on personality

132.—Odd plaster shapes can become definite forms when you use your imagination and a paint brush. Aluminum foil, bent and pushed into a random shape, becomes the mold. Pour puddles of plaster that are thick enough to "stand up" but not so thin that they will spread out like water. You can pour the plaster from a paper cup or drip it off the end of a spoon. As you pour, continue to shape the foil until you are pleased with the general contour.

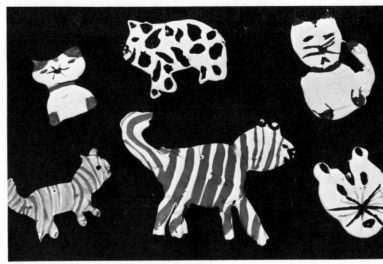

135. Painted animals used for a mobile

133.—When the plaster dries hard (allow about an hour), peel away the foil. Study the plaster shape from different angles until it suggests a form or design. The imagination can visualize some interesting concepts.

134.—The free forms take on personality after they have been painted to resemble caricatures or a flower.

135.—More definite forms can be modeled the same way. Here, sixth-grade students worked the foil into animal shapes, painted them, then made holes with a soaped nail. The figures were strung from a series of bars made from hanger wire, and the result was an attractive mobile.

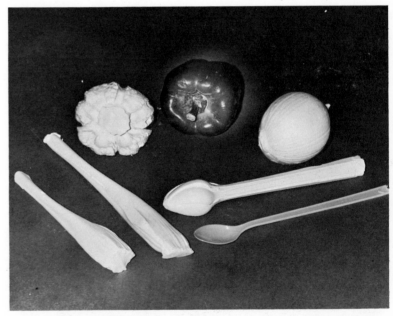

136. Anything can be used for a mold

136.—The possibility for molded forms is unlimited, as illustrated by the examples shown here. It is hard to tell the piece of plaster celery from the real one. The interior of a green pepper, painted green, would fool almost any vegetable shopper; the onion form is a fooler too. Plastic spoons were the mold used for the shape at the lower right. Some of these forms may be assembled into one unusual sculpture.

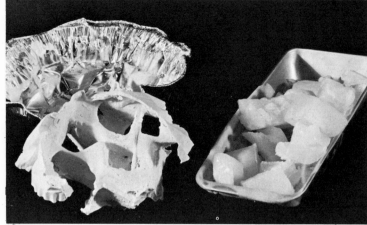

137.

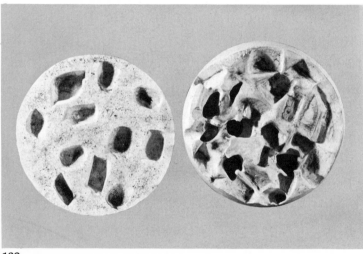

138.

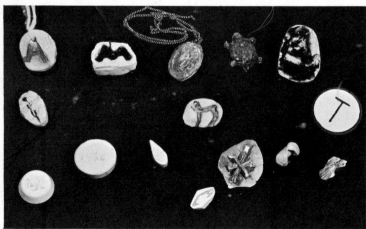

139.

137.—An aluminum-foil pan, a tray of ice cubes and plaster of Paris are the only materials required for a fascinating experience for children. Place the ice cubes in the foil pan. Punch a small hole in the bottom of the pan so that the melted water can run out and not affect the plaster mix. Then pour fast-setting plaster of Paris over the cubes. The chemical reaction of the plaster produces heat as it sets, which melts the cubes quickly but not before they have a chance to leave interesting negative areas in the setting plaster. The pans can be crumbled to give a three-dimensional sculpture effect. The rough form can be chipped, sanded and painted to create a finished piece.

138.—The pans can be left flat so a deep intaglio pattern results from the random placement of ice cubes. The plaque on the left was colored with crayon shavings scattered on the wet plaster surface. The plaque on the right was painted with temperas.

139.—Jewelry can be made from small forms poured into the bottoms of waxed-paper cups or other simple molds. Designs can be made by placing clay in the bottom of the cup or by carving after the plaster has hardened.

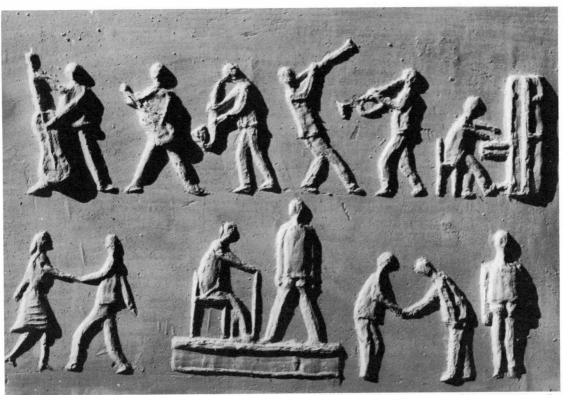

140. MUSICIANS—The plaster block. *All photos of printmaking from blocks courtesy, Dr. Max L. Klaeger, Munich, Germany. Reprinted from ARTS & ACTIVITIES, Feb. 1961, Jones Publishing Co.*

PRINTMAKING

Plaster casting and carving may be combined with printmaking to give students experiences in several methods of artistic expression. A suitably designed plaster carving may be inked and used as a printing block. Thus, the student learns craftsmanship, graphic arts techniques and the interaction of color and design.

The relief block may be made by any of the methods already shown: direct carving, sandcasting, clay or cardboard casts. The figures should be clear-cut and not too close together.

Ink the dry relief block by passing a roller filled with water-base printer's ink over the surface. Place the printing paper over the block and rub gently with a wad of cotton, the fingers or the bottom of a large spoon. Try using various colors, double imprints and similar inventive methods for a variety of imaginative results.

Plaster blocks should be washed with water. If they become too moist allow them to dry before using again. The blocks can be sealed with plastic spray, shellac or other sealer and then inked.

140.—The print of the block shows the gestures of the figures and emphasizes a subtle rhythm. The repeated rectangular shapes provide a stability and solidity to the composition.

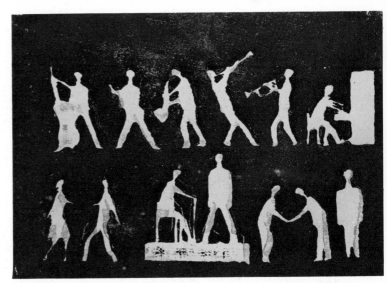

140a. Print made from above block

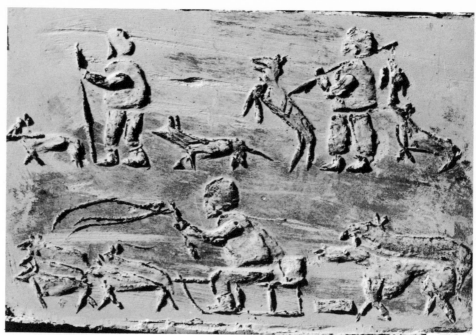

141. WINTER HUNTING SCENE—Block

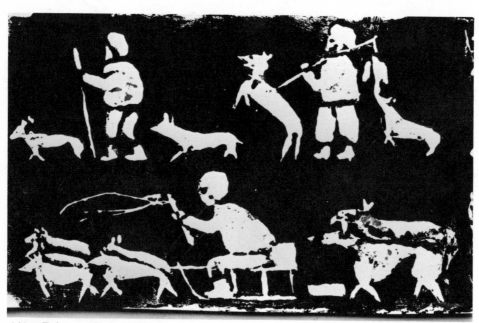

141a. Print made from block

141.—A plaster block was made by pouring about ¾ of an inch of plaster into the top of a well-greased cardboard box. Next, a sketch was made and transferred to the dry block of plaster, then the block was carved to make the relief plaque. To make the print, water-base printer's ink was rolled on the raised portions of the carving. An absorbent rice paper was placed over the inked parts, rubbed, and the print resulted.

When planning blocks to be used for printing, designs with very thin lines should be avoided since they tend to break. Errors and breaks can be patched by adding plaster. Whenever patching is done, moisten the original block before adding the patch to make the added plaster adhere readily.

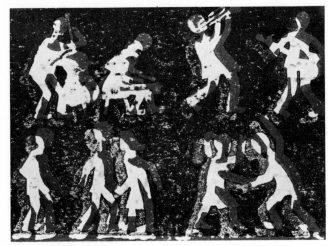

142. THE DANCE

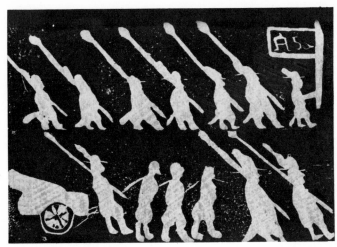

143. THE PARADE

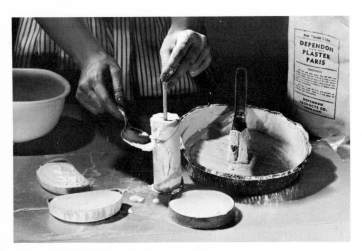

144. Making plaster print forms

145. Printing with the plaster block

142.—Printing the block two or three times with different colors and off-registering the print each time will produce interesting effects. Here, the successive print gives the figures the appearance of motion.

143.—Printing on textured paper, newsprint, or colored paper will give different effects and tones also.

144.—Plaster printing-blocks can be made into many shapes. A roller, simulating a wallpaper printing roller, can be formed by pouring plaster into a greased cardboard tube and placing sticks in the ends for handles. Smooth the surface, cut the pattern, roll in ink and print. You may use a single print or roll the pattern over itself in various colors to create exciting patterns and designs.

145.—Printing shapes may be made in round forms, half-round, etc., combined with lettering, and used for background print textures on programs or posters. Be sure to use sufficient separating medium when pouring plaster into cardboard forms.

chapter 6
TECHNICAL NOTES

There are many varieties of plaster available. Some are for commercial work, dental work or other limited uses. Only the plasters and similar media recommended for art work are introduced and described in this book. When one material is not producing the results desired, there are others that may. It is a good idea to try a few pounds of one or two kinds of plaster to observe their differences and similarities. Then you can try others until you are sure you have the best material for your specific project.

Plaster of Paris is available in any local hardware store. Other plasters and cements may be purchased from lumber-yards and building-supply dealers. The recognized art and schoolroom products are available from art- and hobby-supply dealers.

TYPES OF PLASTER

Plaster of Paris—(Setting time: 6 to 9 minutes) Plaster of Paris must be mixed in small quantities because it sets so rapidly. It has a tendency to be slightly lumpy. A plaster of Paris cast may break or crack easily when dropped because it dries quite hard. However, it is easy to carve. In some cases it is best for use with young children because it sets so quickly.

No. 1 Casting Plaster—(Setting time: 25 to 30 minutes) The most widely used plaster in the arts, casting plaster, is white and fine-textured. It mixes quickly without trapping many air bubbles or forming lumps. It contains a surface hardening additive which helps resist chipping and cracking and reduces paint absorption. It is a little more difficult to carve than plaster of Paris.

White Art Plaster—(Setting time: 25 to 35 minutes) Used mainly for ornamental casting, white art plaster is similar to No. 1 casting plaster, but it is softer and a little more porous.

No. 1 Molding Plaster—(Setting time: 25 to 35 minutes) Because there are no hardening additives, casts made of molding plaster are softer and not so strong as those of No. 1 casting and white art plaster. No. 1 molding plaster is also more porous, so requires sealing with clear lacquer, white shellac or other medium before painting or decorating. It is easy to carve but not recommended for high quality durable work.

Hydrocal-white—(Setting time: 20 to 30 minutes) A general purpose gypsum cement that dries harder and stronger than casting plaster, hydrocal-white may be used instead of plaster. It is easy to pour and reproduces fine detail. It has a smooth, hard surface when dry. For general sculpting, sand- and clay-casting, it is very popular because of its strength. It does not break, chip or crack readily.

Hydrocal-grey—(Same as above but grey in color) Some sculpture, made directly from grey hydrocal, is not colored by other means.

Portland Cement—(Setting time: 3 hours) When portland cement, a fine grey or white powder, is mixed with water it forms a paste which binds together materials such as sand and gravel. As it hardens, it gains strength even greater than that of the aggregates mixed with it. The resulting hard product is called concrete. (Portland cement is a variety of cement—not a brand name.) The initial workability of the paste makes it ideal for molding into a variety of forms. It is used extensively for outdoor sculpture.

Latex-Silicone Liquid—This is a hardening agent that is mixed with portland cement instead of water. The resulting concrete is stronger, yet lighter and more impervious to the weather than portland cement mixed with water.

Crea-stone—This schoolroom product has the workability of plaster with additional features. It is practically unbreakable if dropped. Once dry, if remoistened by soaking it becomes as workable as when first mixed.

Pariscraft—Strips of crinoline impregnated with plaster, Pariscraft is a popular schoolroom craft item. It was originally manufactured for making casts in the medical profession. You simply dip the Pariscraft in water and apply it to a form. It dries quickly and hard. It eliminates the need for mixing individual bowls of plaster for each child and reduces the mess of working with plaster.

VARIABLES AFFECTING PLASTER

Because of its chemical properties, many factors may affect the reaction of the plaster. Frequent problems are lumps, weak casts, erratic setting times, and surfaces that are soft, chalky or full of air holes. The causes of and solutions to these problems are listed below.

Contamination—Often mixing bowls are not clean, causing the plaster to set too quickly. Left-over particles from earlier mixes will incorporate into the new mix, making it lumpy and quicker to set. Make sure all bowls and mixing spoons are clean.

Improper Storage—Plaster should always be stored in a dry place in closed, heavy paper bags, or metal or fibre drums with tight covers. It is a good practice to set large containers of plaster on boards so that the moisture from the floor is not absorbed by the plaster. Plaster which has been exposed to moisture will begin to crystallize and become lumpy. Plaster containing lumps should never be used; removing the lumps is not adequate precaution.

To test a plaster's usability, squeeze a handful firmly. If it feels like flour with small soft lumps it has been exposed to dampness and will not yield best results.

Mixing Time (Overmixing and Undermixing)—The purposes of a plaster-mixing procedure are to wet thoroughly each grain of dry plaster and, at the same time, force air bubbles to escape. Unless all the particles are wet, undermixing results. The plaster mold will not be strong; the surface may be soft and chalky.

Overmixing causes the plaster crystals to dissolve in the water more quickly, thereby speeding up the setting process. Should you mix the plaster beyond the setting point, it will never set as a cast. Excess air bubbles are also a result of too much mixing and cause the dried plaster to appear pockmarked. Agitating the plaster slightly as soon as it is poured will help reduce air bubbles. Tap or pound the work table (depending upon the size of the cast) to force out any trapped air bubbles.

Temperature of Water—Plaster sets most quickly when water between 95° and 105° Fahrenheit is used, because the point of maximum solubility of gypsum in water lies between these temperatures. Higher or lower temperatures lengthen the setting time. Room-temperature water is the safest to use.

Contamination in the Mixing Water—Some waters contain alum or an electrolyte in solution which, when mixed with plaster, may cause rapid setting. Sandcastings made at the beach with ocean salt water also will set rapidly. In general, water that is satisfactory for drinking is best for mixing with plaster.

Hasteners and Retarders—Sometimes it is necessary to speed up or slow down the setting process purposely. Commercial hasteners and retarders are available from your supplier. Follow the directions carefully. Only a pinch of sodate retarder, for example, is necessary in a small mix. You can also control the action purposely by over- and undermixing or changing the water temperature (*See* above). Adding a few shakes of salt to a mixture will also hasten setting time. Hasteners and retarders almost always weaken a cast.

ADDING TEXTURES TO PLASTER

The bone-white smoothness of raw plaster can be varied considerably by three methods: setting a foreign texture on to the surface before the plaster is dry; gluing the texture onto the hard, dry surface; or adding a textured material to the dry plaster before it is mixed.

A sculpture may be revised repeatedly by the addition of materials such as fine silica sand, coarse sand, cellocrete, crushed block, glitter, decorative stone, crushed

colored glass and others. Any of these materials may be sprinkled on top of the wet plaster for texture. As the plaster sets, the material will be embedded. Additional revision may be made by adding a texture to the dried sculpture with airplane glue.

A texture material added to the plaster powder before it is mixed with the water completely changes the appearance, yet rarely changes the strength and sculptural quality of plaster. Adding a few teaspoons of baking soda to the mixture causes a chemical reaction; the plaster dries with a sponge-like, bubbly texture.

When vermiculite is added to the mix, an interesting, rough, masculine texture results and the weight of the finished piece is reduced considerably. Because vermiculite is soft, the finished block is easier to carve than one of solid plaster. The mottled gray color of the vermiculite dominates the block. The proportion of vermiculite to plaster can be altered to achieve a wide range of effects.

Sawdust, marble chips, terrazzo, sand, zonolite and used coffee grounds may also be mixed with plaster to vary the texture. Two materials may be combined. Generally the texture material should be in a maximum ratio of three parts to one part of plaster. Experimentation will give you the results you want.

The texture material may be mixed first with the dry plaster then with water, or added quickly but thoroughly to a thin mixture of plaster and water. The final mixture should be of a pouring consistency. There must be enough plaster to make all the materials adhere to one another and still result in a strong, finished cast.

For extra hardness, particularly when you are mixing a foreign material with plaster, add a solution of 50 per cent Elmer's glue and 50 per cent water to the mix. Also, the glue reduces chipping.

146.—Shown are a few of the textures that can be achieved with plaster. Top row, left to right: in the first four examples, texture has been glued on by adding fine sand, coarse sand, vermiculite and cellocrete. The bubbly texture in No. 5 was made by adding a few teaspoons of baking soda to the plaster mix. Bottom row: the wet plaster has been striated with a comb, a piece of mesh screening impressed, and only the fingers used to make the third design.

147.—Deep gouges made with sharp instruments give this sculpture a rich surface texture.

148.—Hemp dipped in the plaster makes it airy, strong and original-looking, completely changing the appearance of plaster.

149.—A comb and other sharp instruments were used to create the surface linear design that carries out the movement of the main elements of the sculpture.

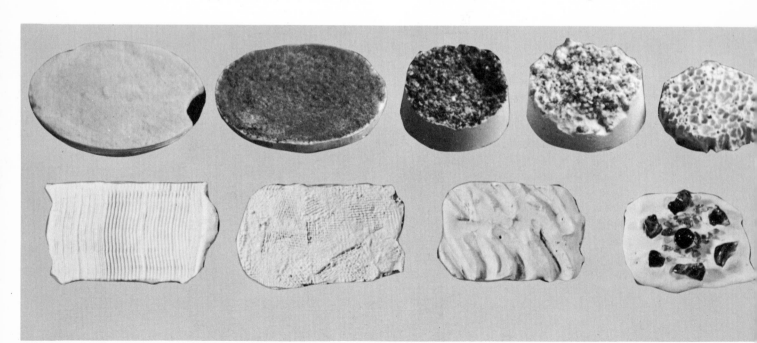

146. Surface textures added to plaster

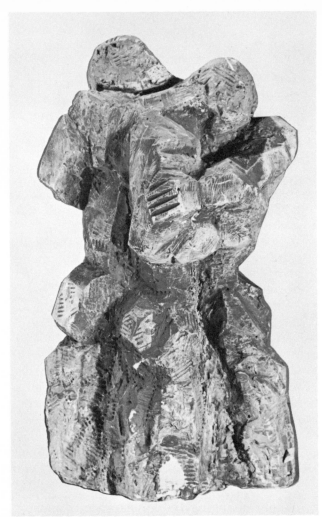

147. EMBRACE *Si Gordon*

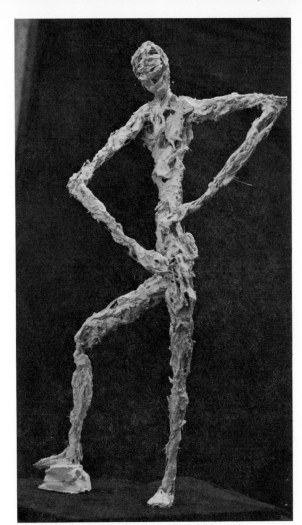

148. STANDING MAN *Albert Vrana*

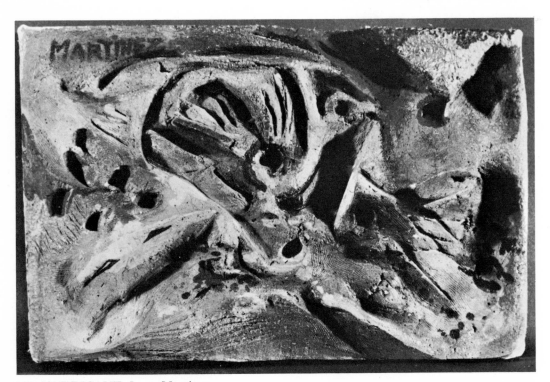

149. HURRICANE *Jerry Martinez*

COLORING AND FINISHING

From the time plaster was first used, people realized that its chalky white surface could be made more appealing with decoration. An early technique called *fresco* was developed. Examples of fresco are found on the walls among the ruins of the early Greek, Egyptian and Pompeian civilizations. But fresco painting was brought to its glory in the fourteenth and fifteenth centuries in Italy. Then, Renaissance painters decorated the interior walls of the churches with religious subjects.

The fresco process involves adding a paint medium to fresh, wet plaster. First, a design is made and transferred to the dry wall. A thin layer of wet plaster is spread over the wall, and then the coloring painted on. Variations of this technique are still used today on walls and plaster sculpture. A water-base paint, added to wet plaster, is partially absorbed by the plaster as it dries. The result is often a soft hue of color and tonal quality. Paints that are adaptable to wet plaster are temperas, caseins, water colors, drawing inks and dyes used for fabrics.

When paint is applied to hard, dry plaster the color quality will be heavier and truer. Any paint, water- or oil-base, may be used to create the unending variety of effects illustrated throughout this book. Oil paints, glazes, acrylics, enamels, flat and glossy paints may be sprayed or brushed on. Young children may use crayons and magic markers. The plaster should be thoroughly dry before using these paints. If paint is coated over slightly damp plaster, it tends to crack and peel off in time.

Porous plasters should be sealed before they are painted. Use a clear plastic spray, clear shellac, or brush on a solution of 50 per cent Elmer's glue and 50 per cent water.

Black paint will give the plaster a metallic-looking quality. Silver and bronze patinas may be simulated. Silver and bronze powders should be mixed with a solution of clear lacquer and alcohol in equal parts. A mixture of ochre oil paint and linseed oil will produce an antique finish.

You can obtain various effects by mixing powders such as tempera, cement and mortar coloring with the dry plaster or with the water, or while you are stirring the two together. For a marbelized effect, try adding small balls of powder color to the dry plaster. Parts of the color will dissolve, leaving large strokes and tails of color in the cast. For more control over a color, add the powder while you stir rather than to the water alone. A liquid color is best mixed with the water for over-all toning of plaster.

With portland cement, use commercially pure mineral pigments. Other pigments are likely to fade or reduce the strength of the concrete to a marked degree.

A sealer coating will help to keep a plaster sculpture in its original white state. A half and half Elmer's glue and water solution, Krylon plastic spray, clear lacquer or clear shellac are best. Sometimes shellec will turn slightly yellow. Do not use orange shellac. If a plaster sculpture becomes dirty, immerse it in water and let it soak. After a while rub the loosened dirt with a sponge while the sculpture is still under water. The dust that floats to the top should be skimmed off with a blotter or large spoon. When no dust remains on the water's surface, lift out the sculpture and let it dry in a dustproof place.

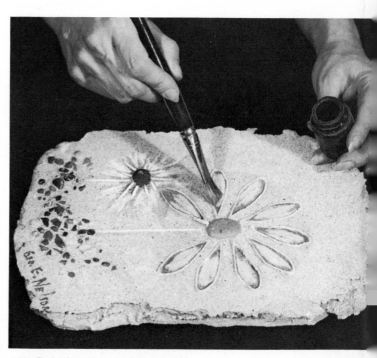

150. Painting the sandcasting

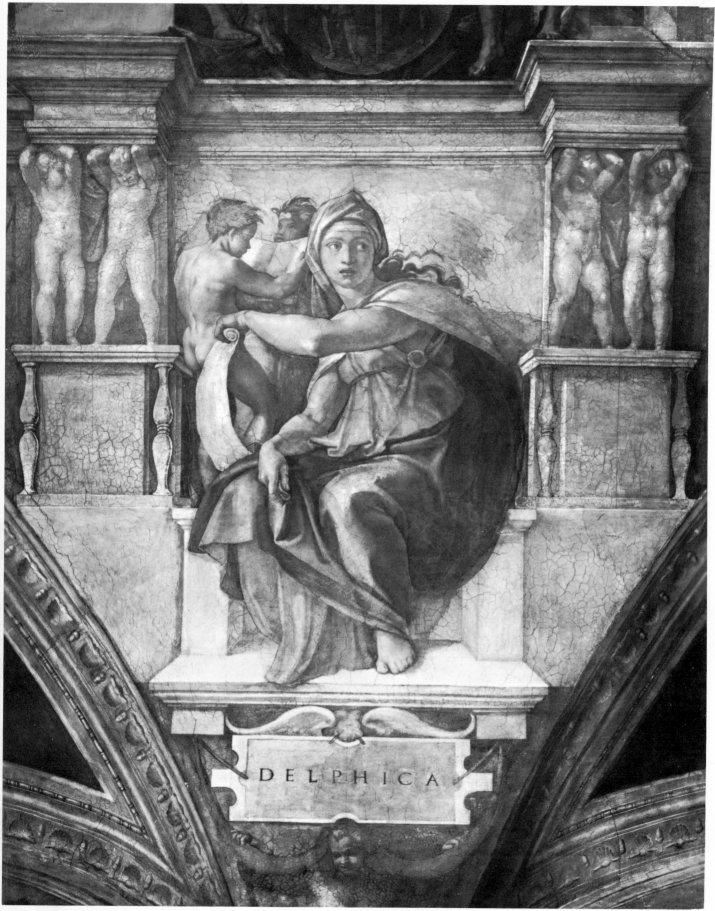

151. THE DELPHIC SIBYL *Michelangelo. Courtesy, Gallery Allinari, Florence.*